For Mother and Daddy !

Love, Kristin August, 1994

The Best of

COLORED PENCIL

Two

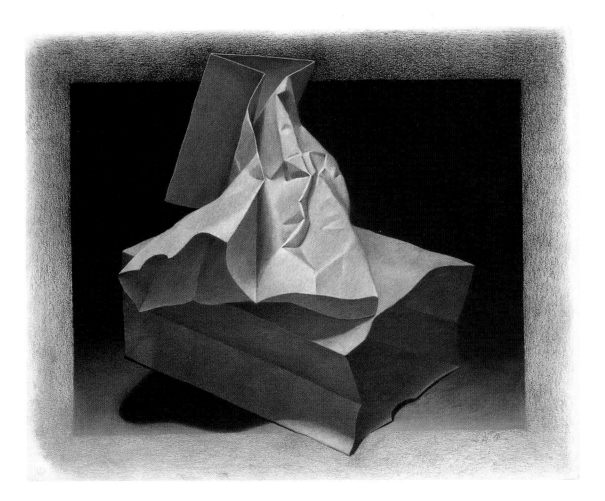

THE BEST OF COLORED PENCIL TWO

DESIGN/LAYOUT
SARA DAY

EDITOR
ROSALIE GRATTAROTI

PRODUCTION MANAGER
BARBARA STATES

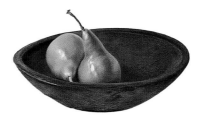

<div style="text-align: right">Nancy Blanchard Illustration</div>

First published in the United States of America by:
Rockport Publishers, Inc.
146 Granite Street
Rockport, Massachusetts 01966
Telephone: (508) 546-9590
Fax: (508) 546-7141
Telex: 5106019284 ROCKORT PUB

Distributed to the book trade and art trade in the U.S. and Canada by:
North Light, an imprint of
F & W Publications
1507 Dana Avenue
Cincinnati, Ohio 45207
Telephone: (513) 531-2222

Other distribution by:
Rockport Publishers, Inc.
Rockport, Massachusetts 01966

ISBN 1-56496-108-7

1 3 5 7 9 10 8 6 4 2

Printed in Singapore

The Best of

COLORED PENCIL

Two

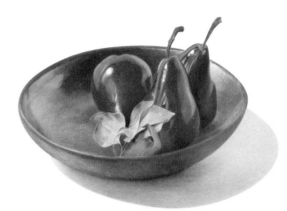

Nancy Blanchard Illustration

ROCKPORT
PUBLISHERS

Rockport Publishers, Inc. • Rockport, Massachusetts

INTRODUCTION

"Yes. It's colored pencil." That confirmation was an echoing refrain as hundreds of guests attended the opening reception of the first CPSA International Colored Pencil Exhibition. The wide variety of subjects was greeted with audible amazement as viewers realized these "paintings" were accomplished without a brush. From abstract and whimsy to photo-realism, the "humble" colored pencil exceeded any stereotypical expectations of its capabilities.

Sponsored by the Colored Pencil Society of America (CPSA), this exhibition featured the award winners of, and other juried entries to, the first annual international competition. The competition was open to both CPSA members and nonmembers. The rules were simple: 100% colored pencil done in any style, subject, or category. Over 750 slide entries were submitted for initial jurying. The final entries and award winners were selected from the original artwork of ninety-seven artists. We sincerely thank our judge, Ellen Sharp, Graphic Arts Curator of the Detroit Institute of Arts, for making such difficult choices.

This premiere exhibition was a wonderful celebration of the medium and a sincere tribute to those who use it. I am truly grateful to our talented members and other exhibiting artists for making it a success. Behind this achievement are the efforts of the committees, officers, patrons, and sponsors whose contributions made a difference—not only for this exhibition, but throughout the year. Special appreciation goes to Ken Gross, Executive Director, and his staff at the Birmingham/Bloomfield Art Association in Birmingham, Michigan.

In an era of multimedia, high-tech manipulation, the colored pencil has finally come of age. We salute those who so masterfully use this pure and unpretentious art form. Included within these pages, along with the work of the exhibiting artists, are other notable entries. And as you enjoy the diverse range of styles and techniques, please remember that, "Yes, It's colored pencil."

Vera Curnow
Founder
Colored Pencil Society of America

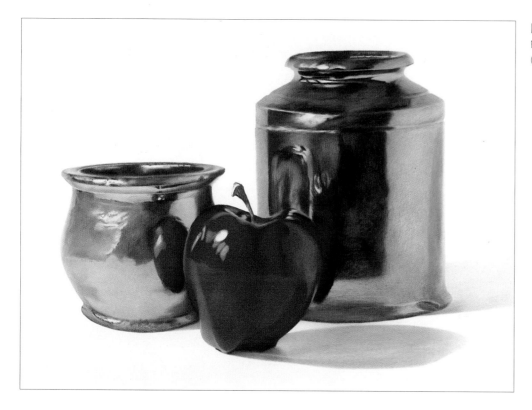

NANCY BLANCHARD
Red Delicious (above) 22 ¼" x 30"
(below) 22 ¼" x 30"

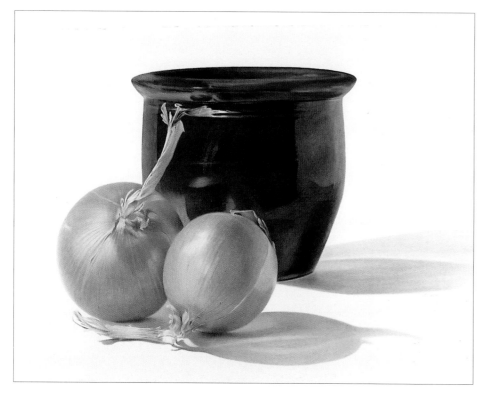

NANCY BLANCHARD

Porridge Bowl *(above)* 23" x 29"
CPSA Award for Outstanding Recognition

(below) 22 ¹/₄" x 30"

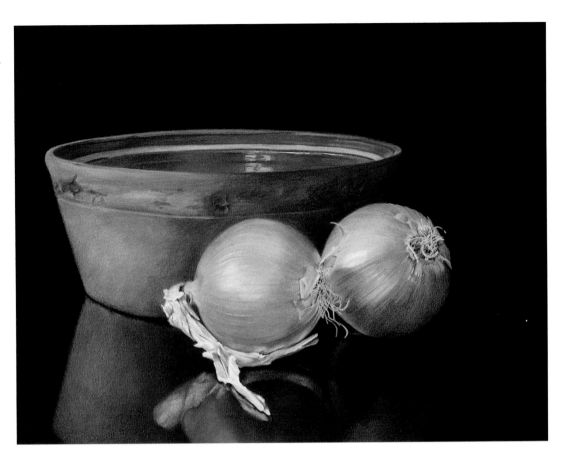

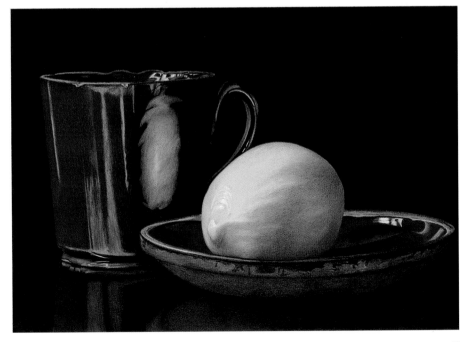

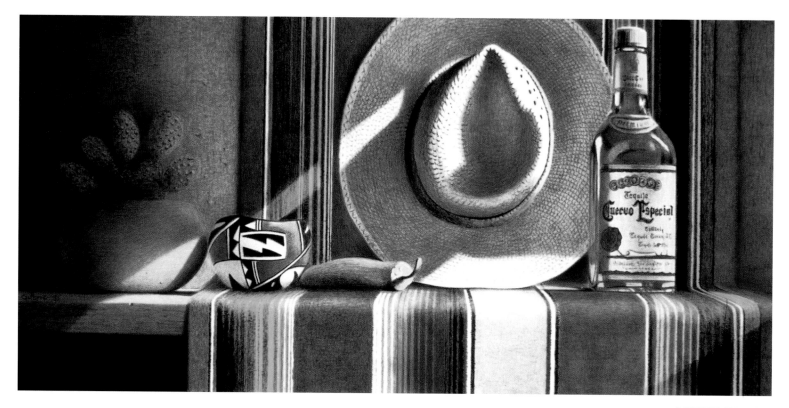

ROBERT GUTHRIE
Tequila Sunrise 8 ½" x 17"

ROB FLEMING
Ancient 14" x 14"

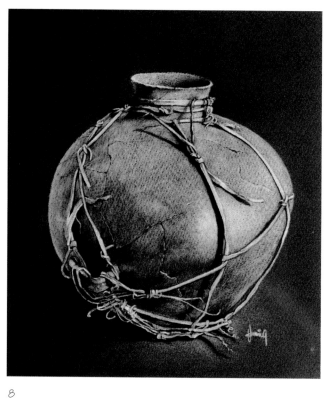

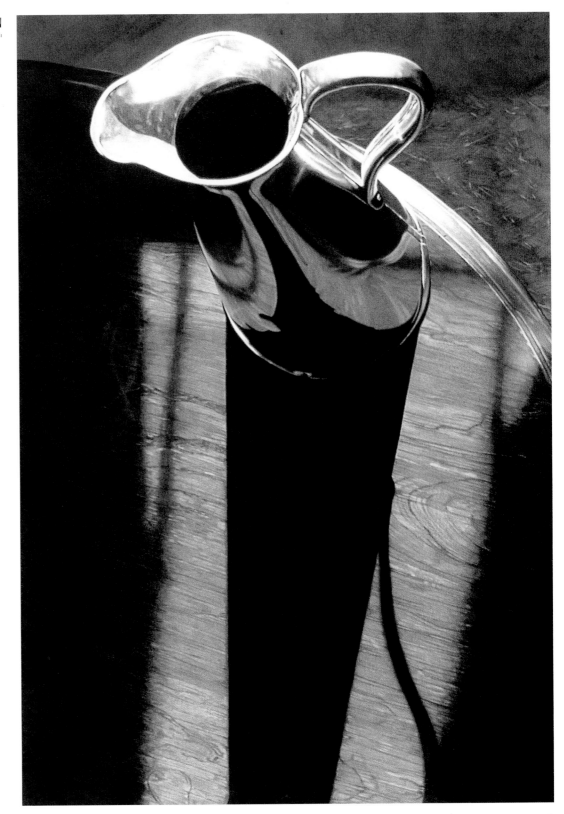

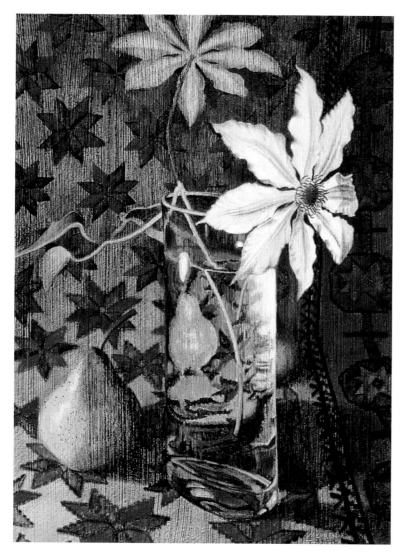

(clockwise from top left)

MERREN FRICHTL
Magic Carpet II 24" x 20"

ROMAN DUNETS
Corn 7 ¾" x 8"

JAN RIMERMAN
Egyptian Soul 43" x 26"

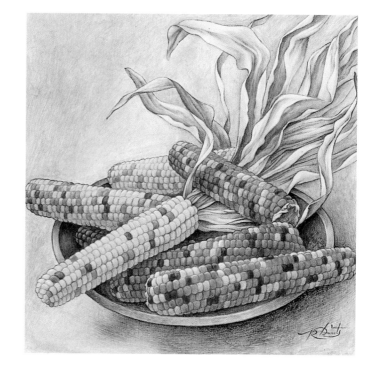

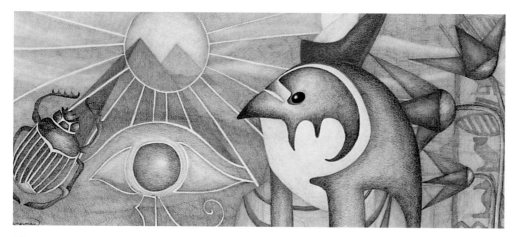

JOE BASCOM

Brown Paper Bag Drawing
No. 56 *(above)* 23" x 29"
Artistic Merit Award

Brown Paper Bag Drawing
No. 63 *(below)* 23" x 29"

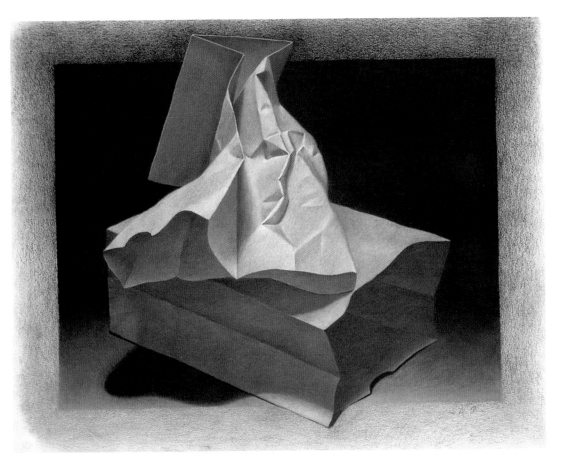

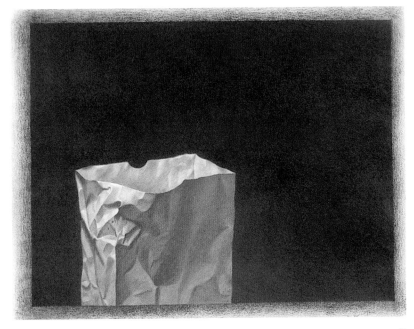

SUSAN AVISHAI
Terracotta Silk 16" x 16"
Gallery Alliance Award

NIKKI FAY
Moonscape Sahara 17" x 31"

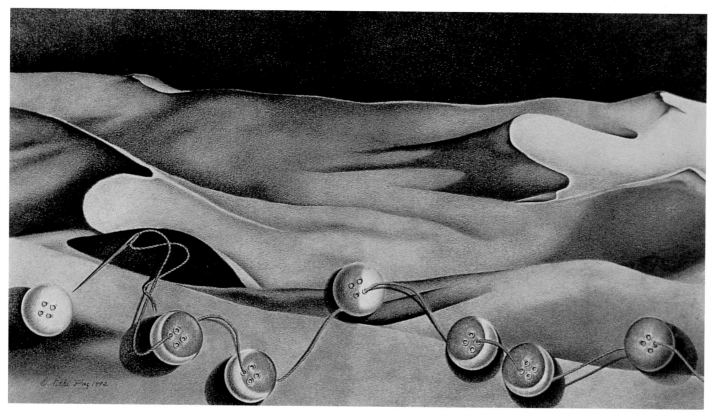

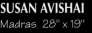

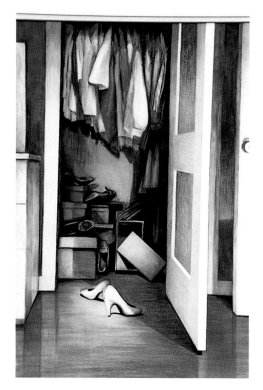

JEFFREY SMART BAISDEN
Steppin Out 30" x 23"

CONSTANCE W. SPETH
Room with Light #5 23" x 29"

ANN KULLBERG
Helium 23" x 40"

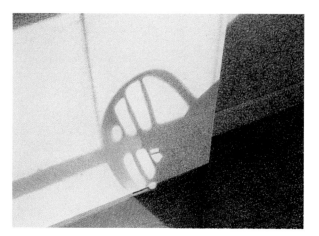

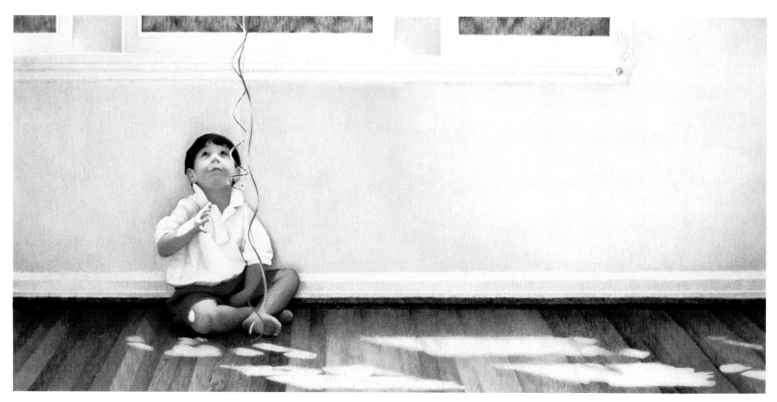

JOANNE SMITH WOOD
Utah Apricots '92 15 ½" x 19 ½"

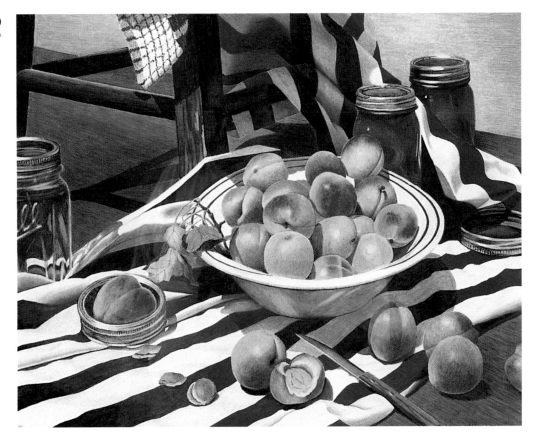

DON SULLIVAN
Three Number Two's 10" x 14"

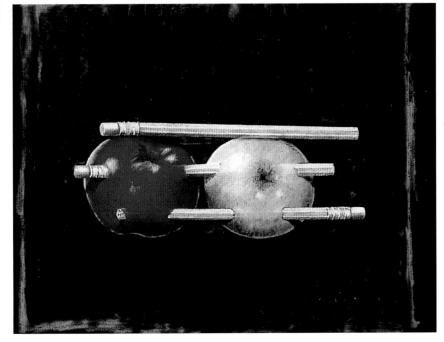

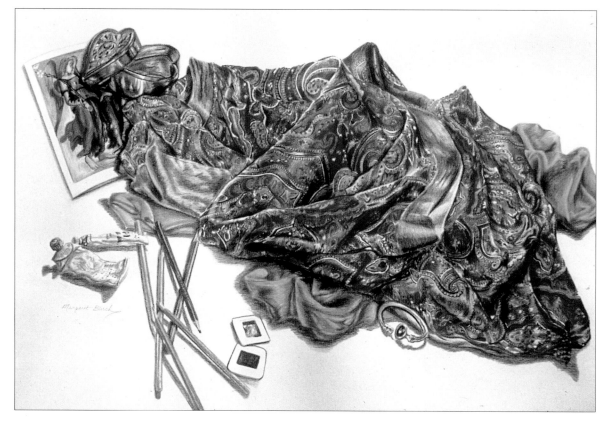

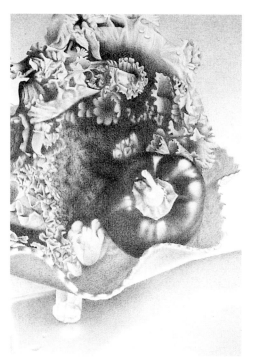

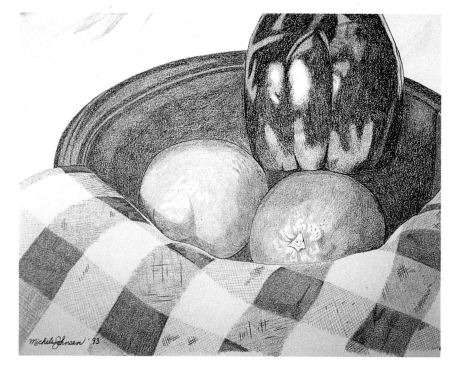

16

WENDY J. HILDEBRAND
Red + White Blues 7 ³/₄" x 9 ¹/₄"

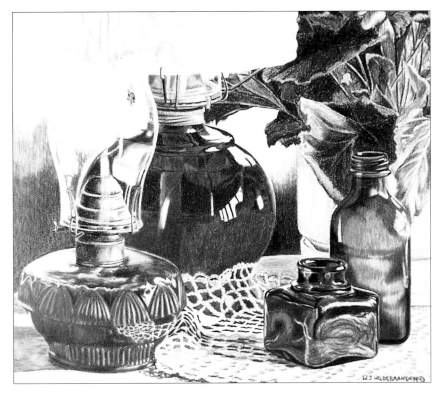

MARGURITE D. MATZ
Tea for Some 23 ¹/₂" x 29 ¹/₂"

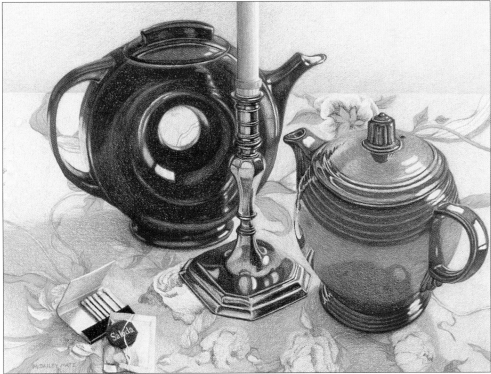

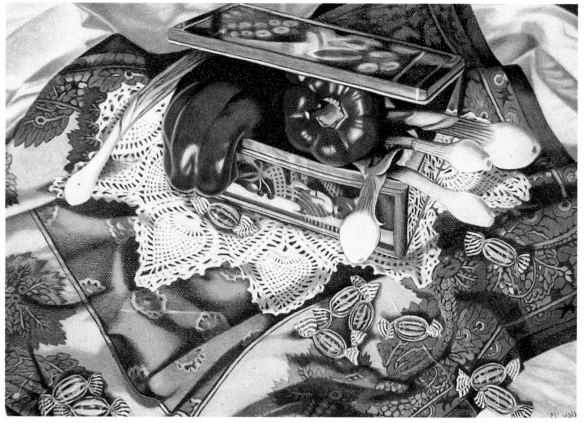

RONNI WADLER
A Balanced Meal #2 25" x 32"

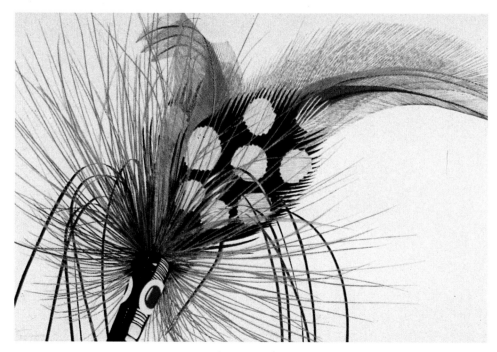

BETH WARD-DONAHUE
Purple Pimpernil 22" x 28"

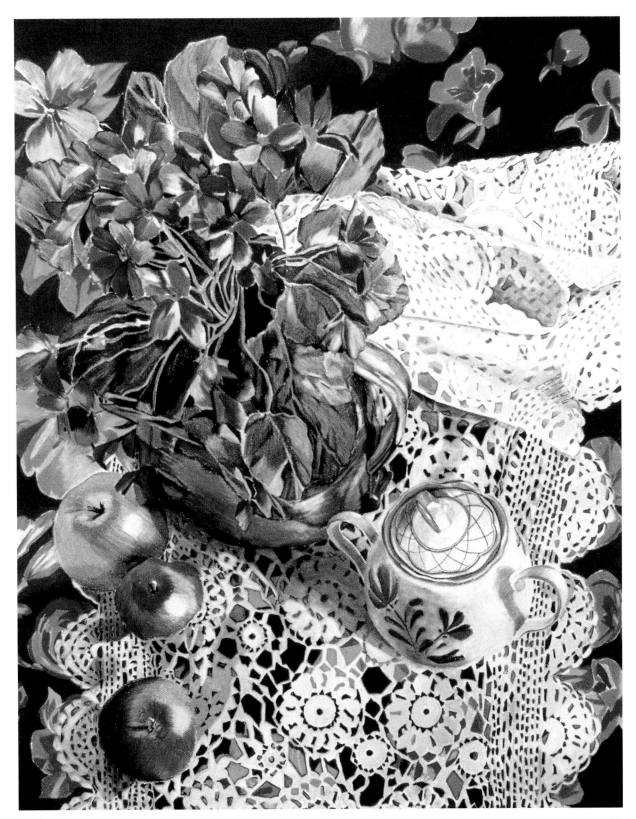

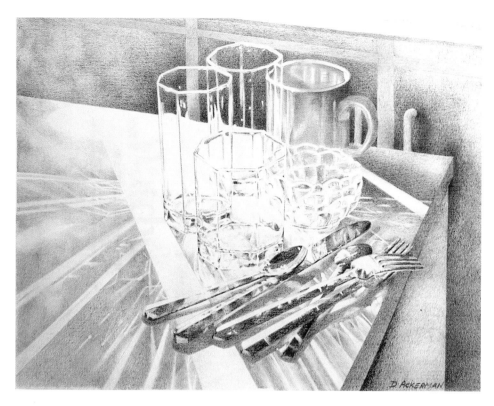

(clockwise from top)

DEANE ACKERMAN
Sunglasses #2 18 ¾" x 21 ¼"

JOYCE DUNN
Aztalan 38" x 30"

R.K. HILLIS
Homage to Balthus 26 ½" x 19 ½"

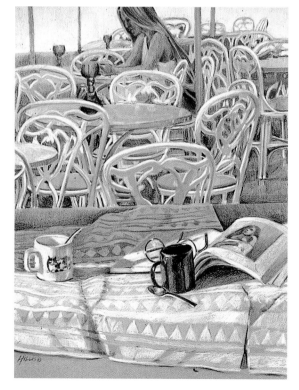

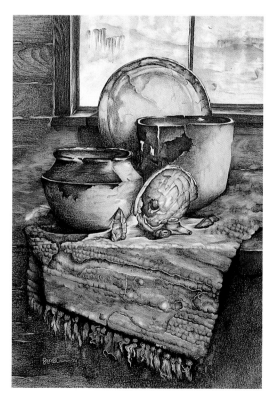

SHERRY LOOMIS
Only the Best 22" x 31"

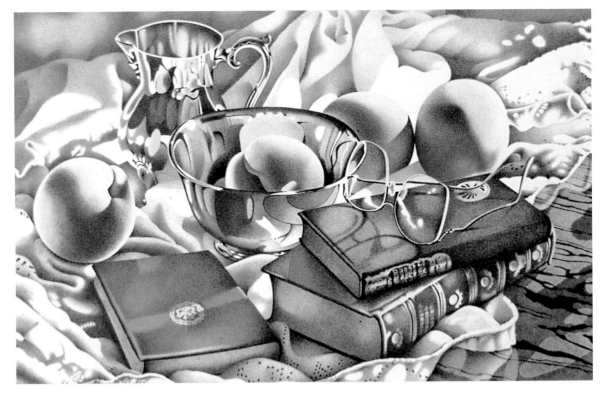

DIANE VESTIN
Four By Four 20" x 26"

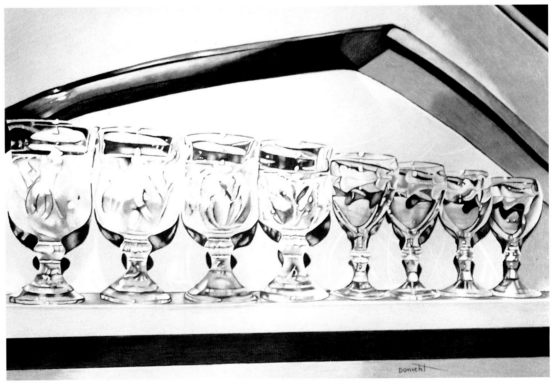

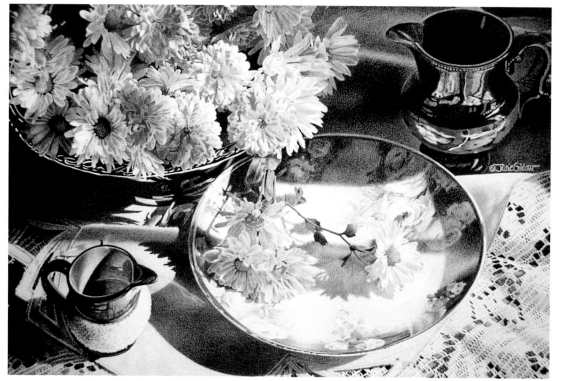

JANE A. GILDOW
Lustre and Lace 18 ¼" x 23"
Eberhard Faber Award

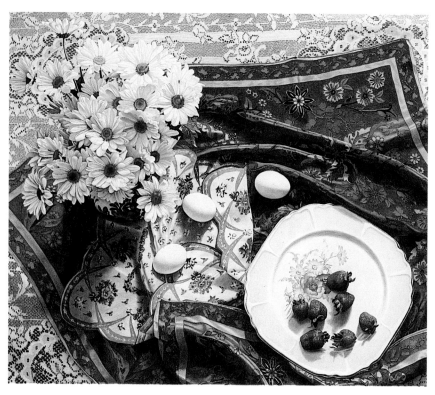

BARBARA EDIDIN
My Darling, My Daisy 23" x 27"

(facing page)
Over the Rainbow 19" x 16"

22

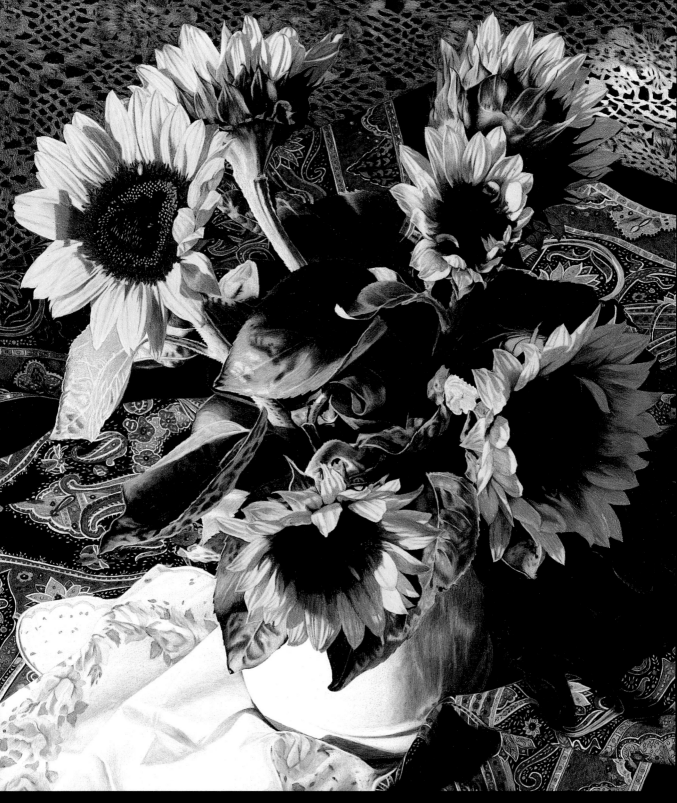

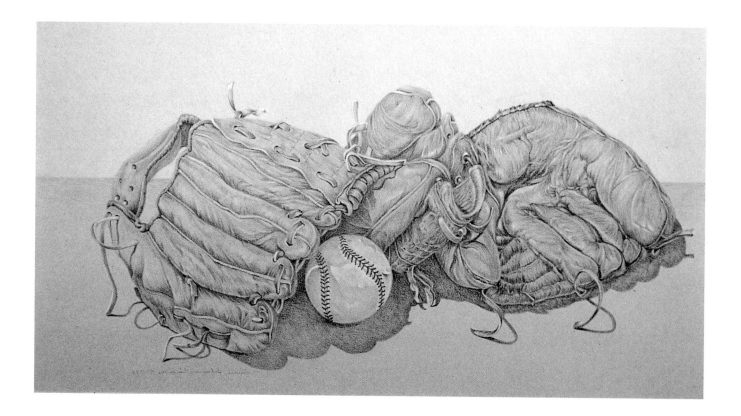

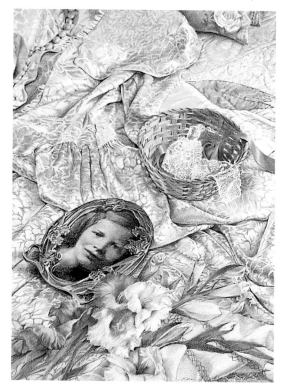

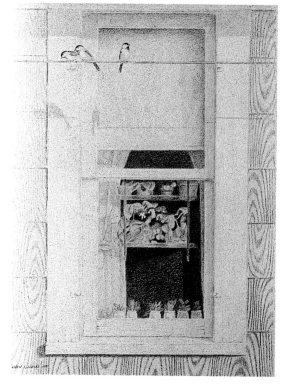

LAURIE SCHIRMER CARPENTER
..., Mom and Apple Pie 19" x 30"

BARBARA RICHARDS
Window Peepers 36 ½" x 28 ½"

KAREN MARTIN
Vows and Gladiolas
27 ¼" x 22 ½"

JILL KLINE
Breakfast to Be 18" x 17"

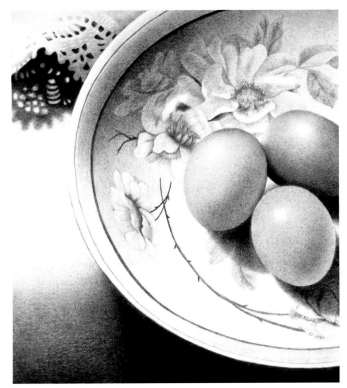

DAVA DAHLGRAN
Offspring 29 ¼" x 37"

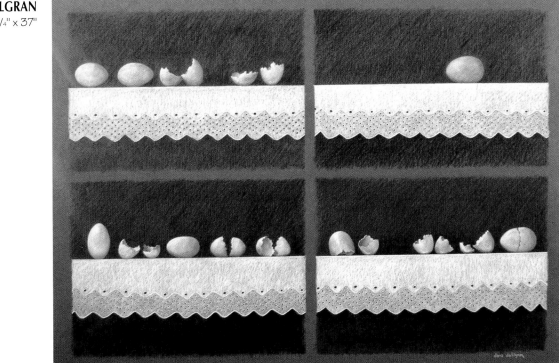

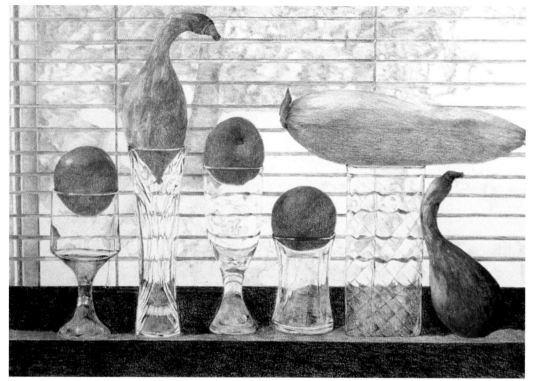

LINDA HEBERLING
Window Dressing (above) 14" x 21"
Sitting Pretty (below) 16 1/4" x 19 3/8"

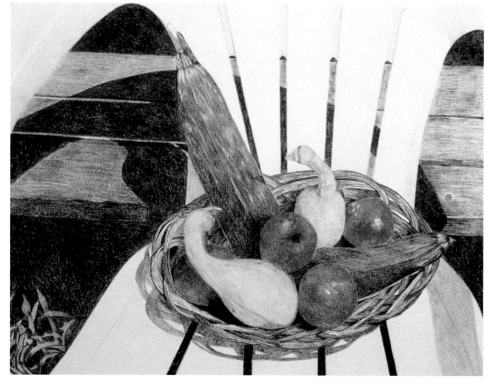

JANE GILDOW
And the Phone Rang 10" x 14"

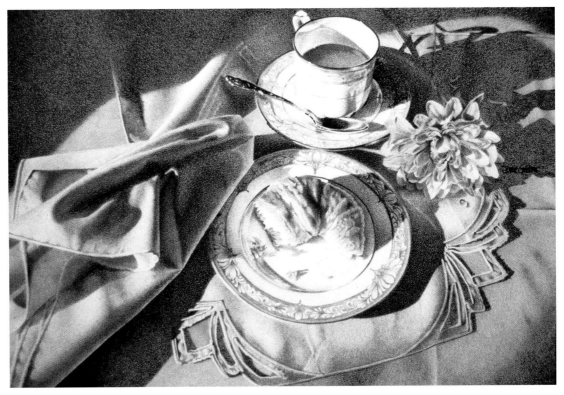

MARIANNE ANDERSON
Untitled 10 ³/₄" x 24"

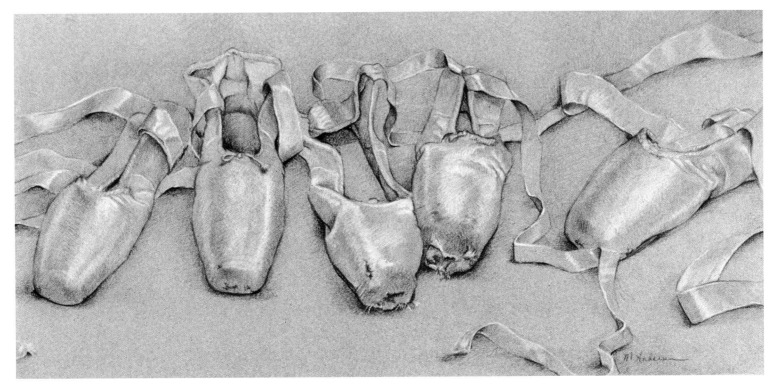

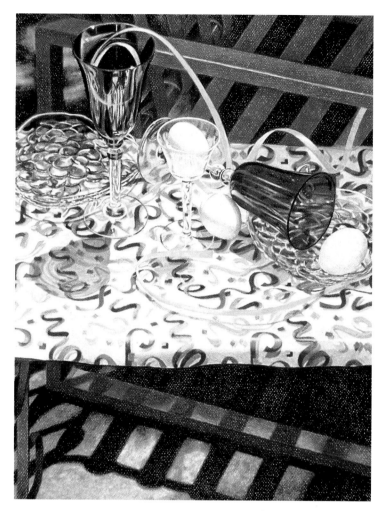

RONNI WADLER
Spring Fling 27" x 24"

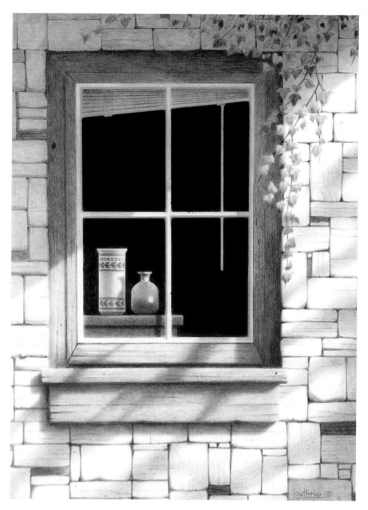

ROBERT GUTHRIE
Last July 13 ½" x 10"

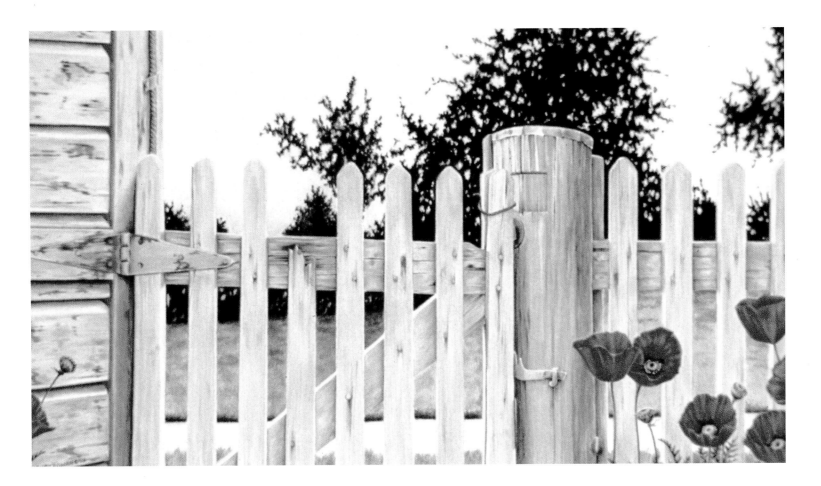

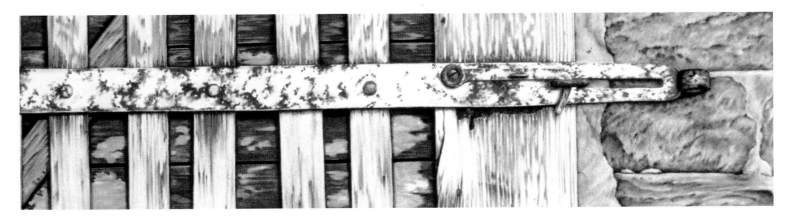

BRAD STROMAN
Poppies By The Gate *(above)* 16" x 28"
Passageway *(below)* 7" x 28"

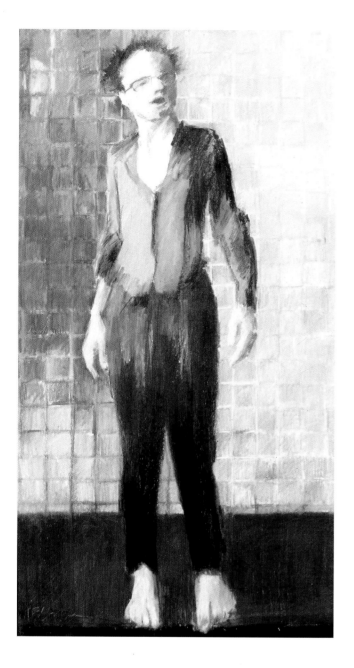

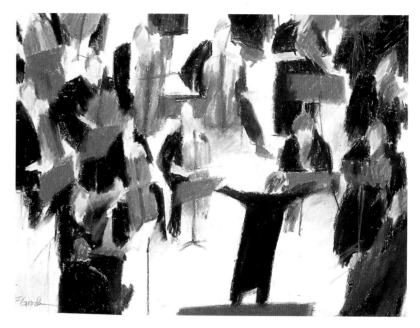

JEANNE GOODMAN
The Symphony *(above)* 17" x 21"
In The Tiled Room *(left)* 32" x 20"
Artistic Merit Award

BILL NELSON
Lady Be Beautiful 14 1/2" x 10 1/2"

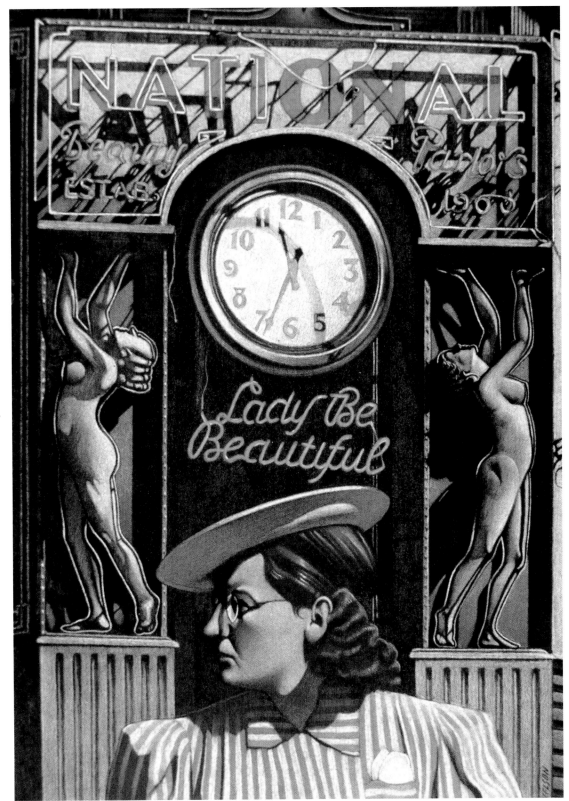

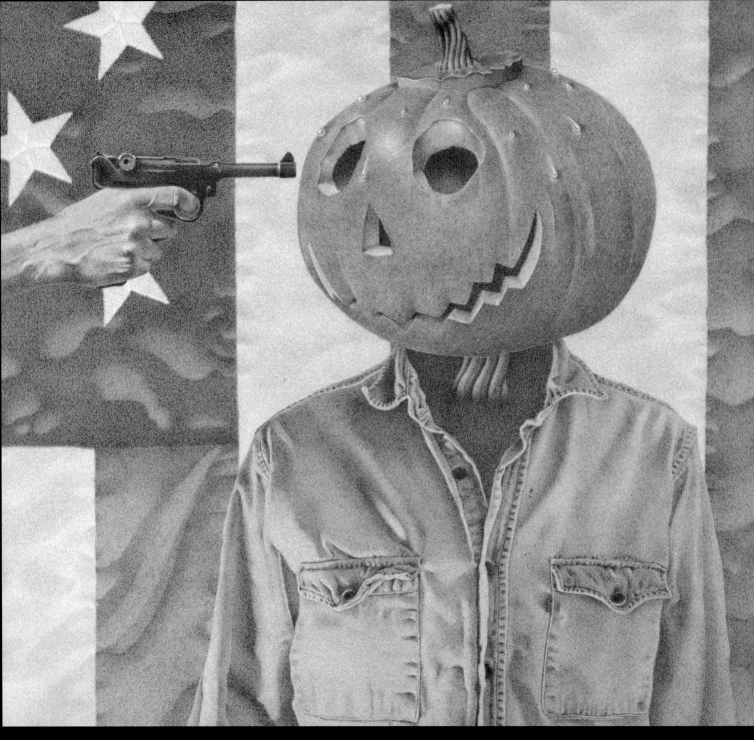

CHARLES DEMORAT

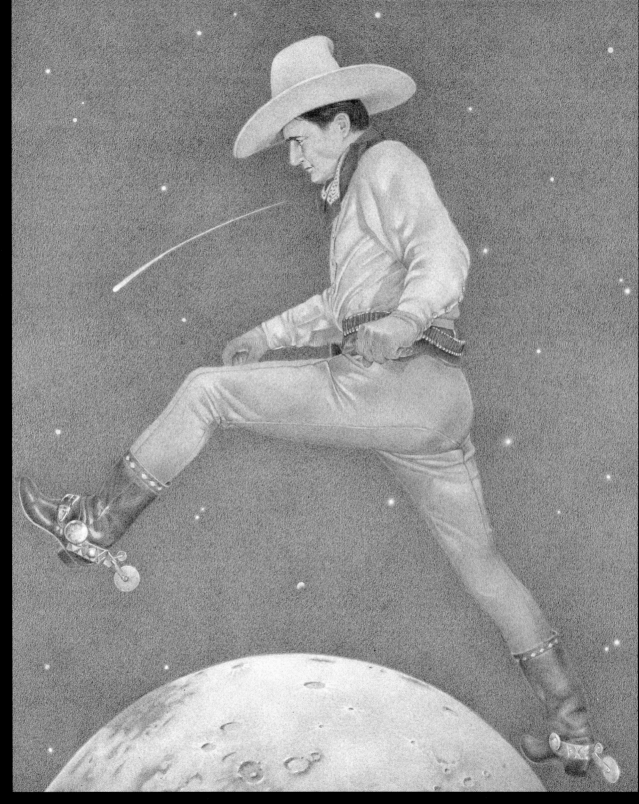

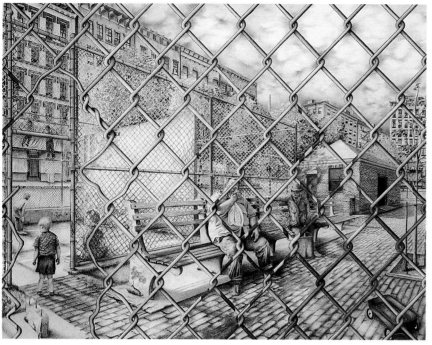

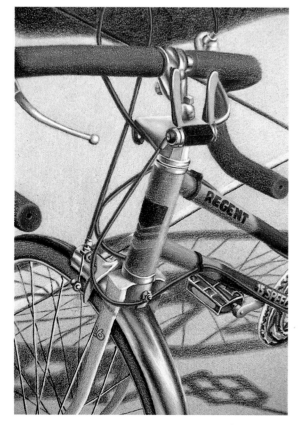

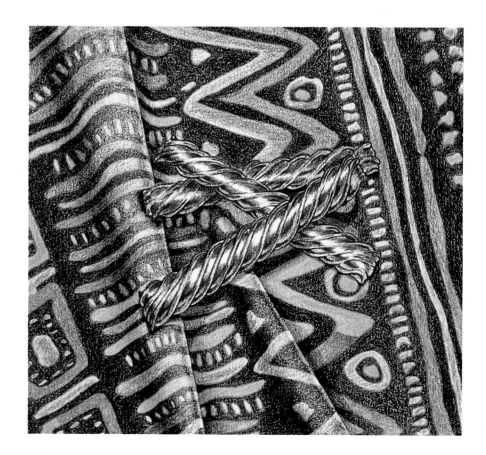

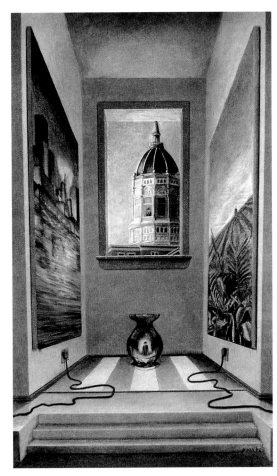

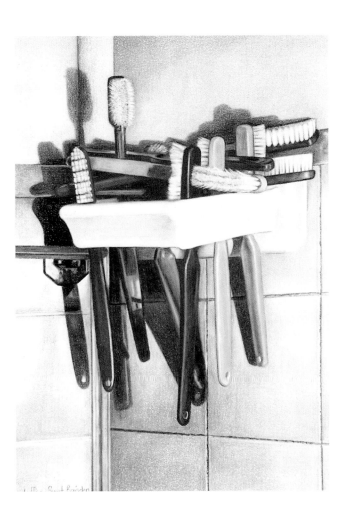

(clockwise from top left)

PHILLIP MICHAEL HOOK
Cycle: Education, Production
and Consumption 24" x 16"

JEFFREY SMART BAISDEN
The Extended Family 22" x 18"

MERREN FRICHTL
Momo 16" x 16"

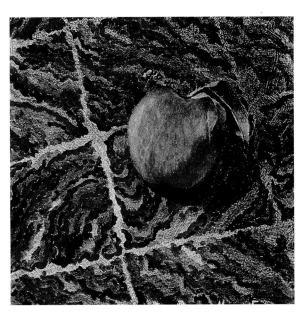

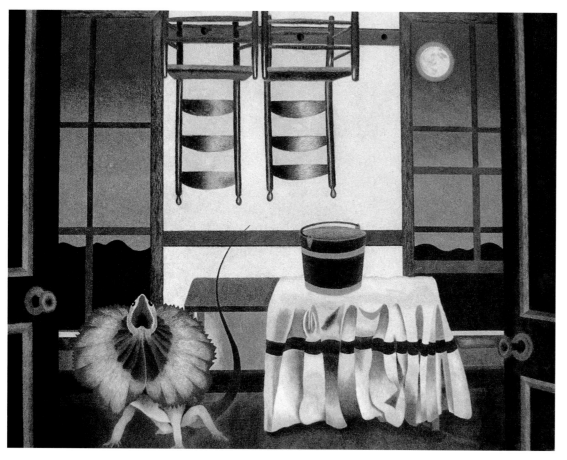

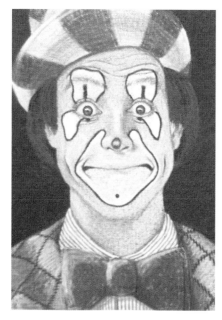

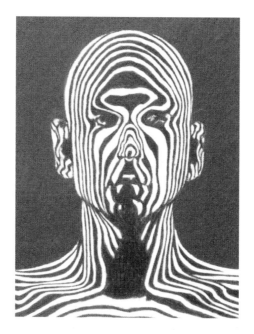

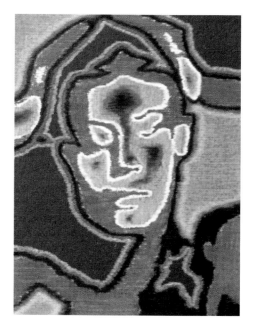

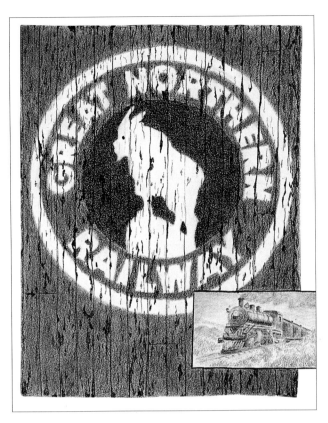

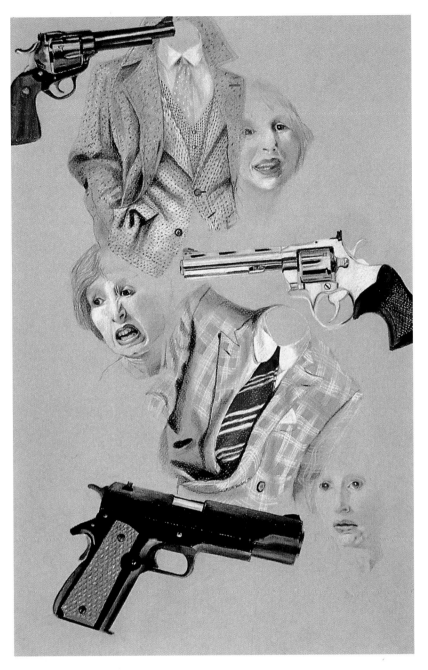

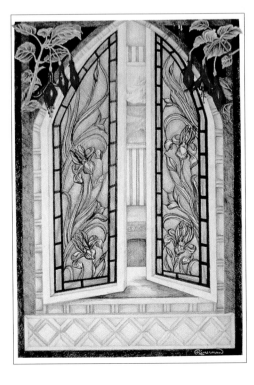

(clockwise from top left)

JUNE GRAY
The Old Goat 18" x 16"

MARGO VANHORN
Hijacked 32" x 24"

JAN RIMERMAN
Inner Solace 38" x 30"

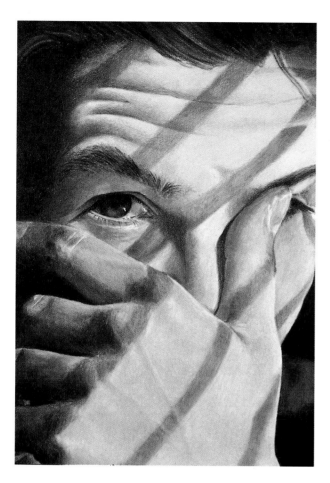

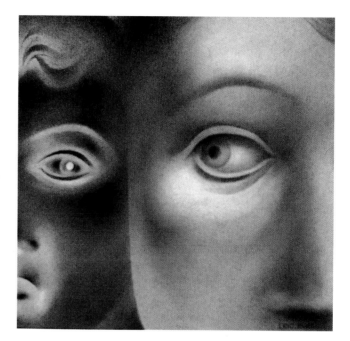

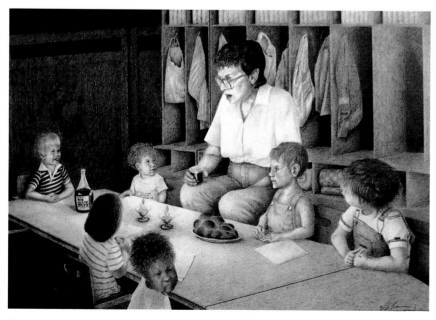

(clockwise from top left)
BONNIE D. AUTEN
Untitled 11 ½" x 16 ½"
CPSA Members' Award

ERIC BYARS
Alter Ego 12 ¼" x 13"

PHIL WELSHER
Shabbat in the Infant Room 14" x 20"

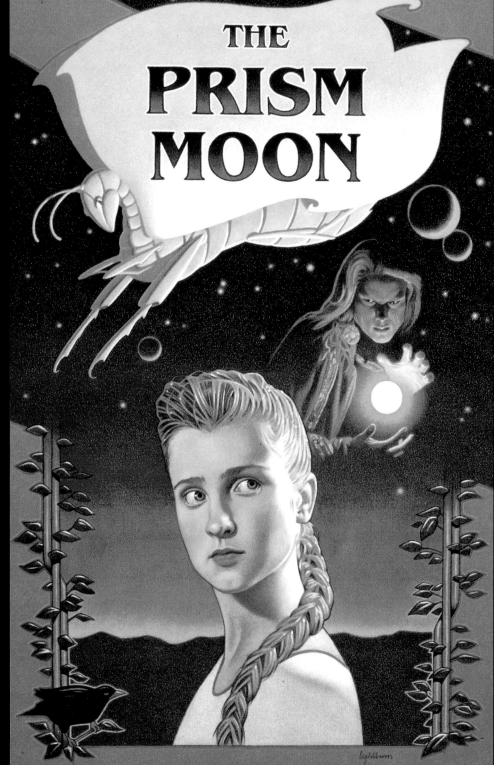

THE PRISM MOON

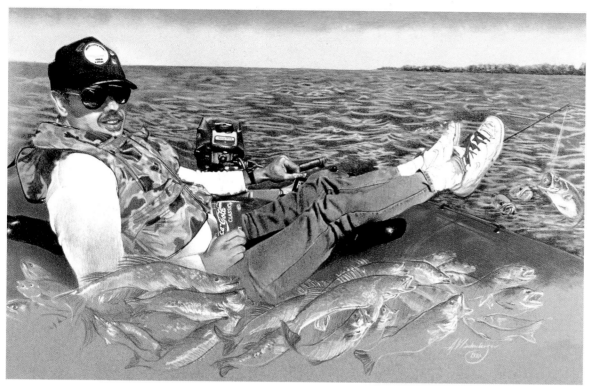

AMY V. LINDENBERGER
Captain Kurt's Fishing Fantasy
24" x 36"

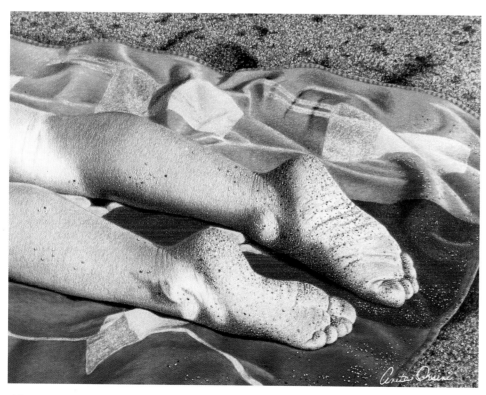

ANITA ORSINI
Wet Sand, Warm Son
10" x 14"

(facing page)
RON LIGHTBURN
The Little Girl Learned Each Tree

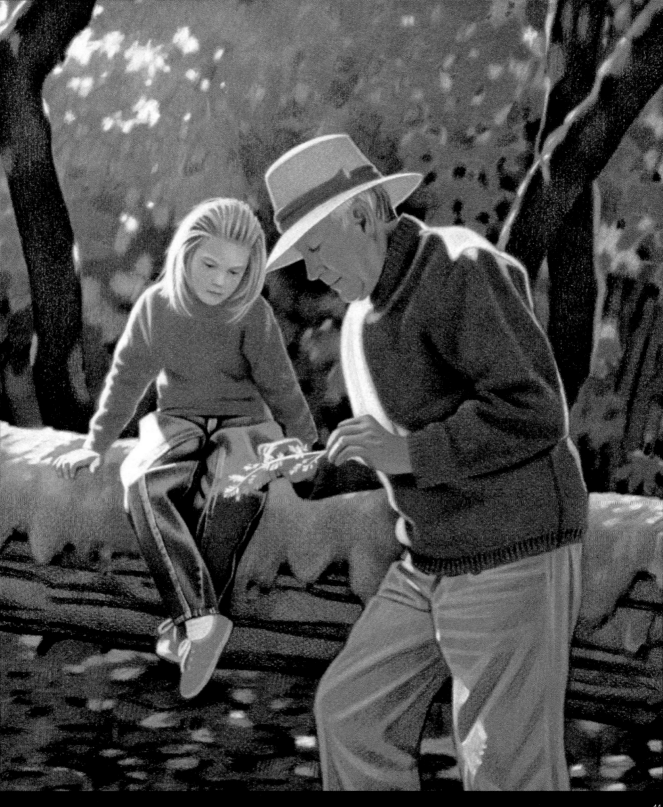

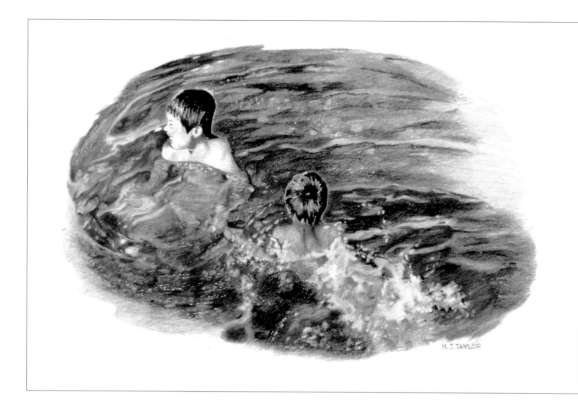

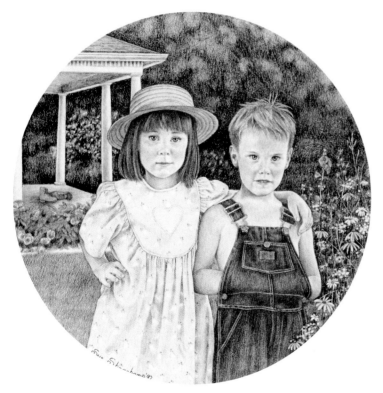

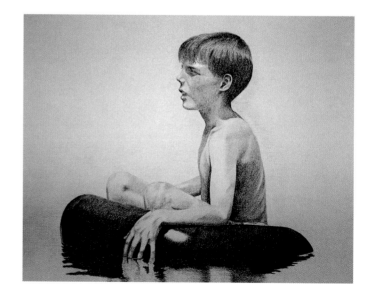

LINDA HUTCHINSON
Arachnophobia 13" x 16"

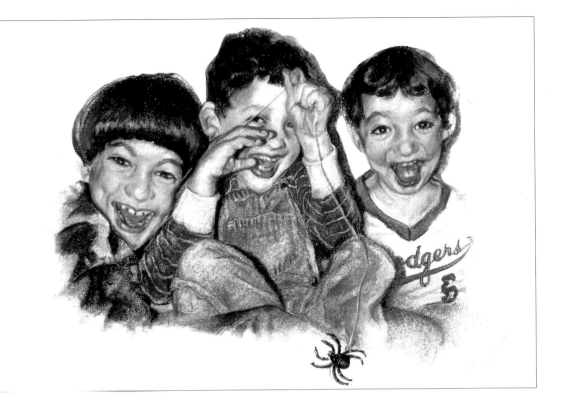

SORY MAROCCHI
Fue, Aspiring Physician
31" x 32"

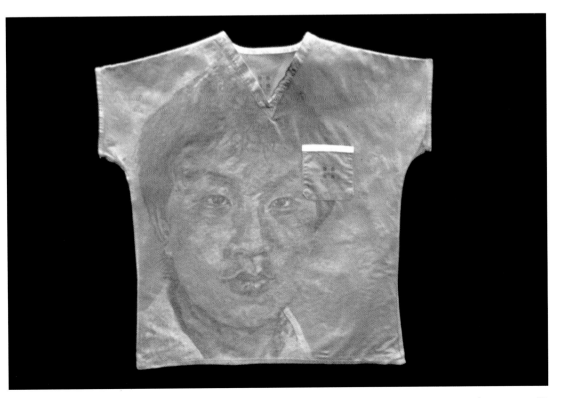

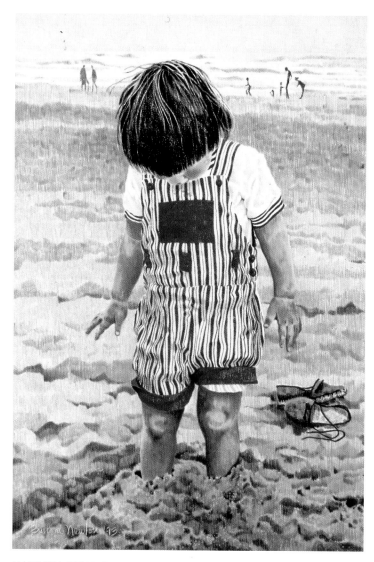

BARBARA NEWTON
Jillie 18 ¼" x 13"

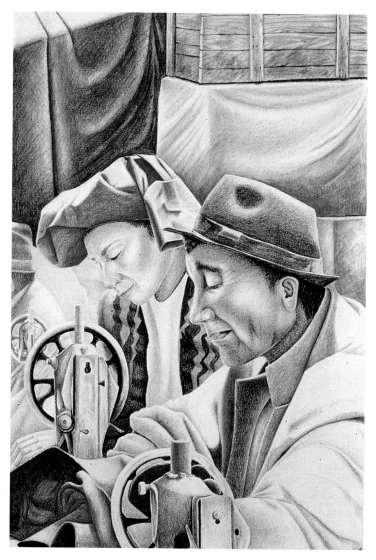

JAQUELINE LUKOWSKI
The Tailors of Latacunga 20" x 13"

WALTER PETERSON
Saturday Afternoon 24" x 30"

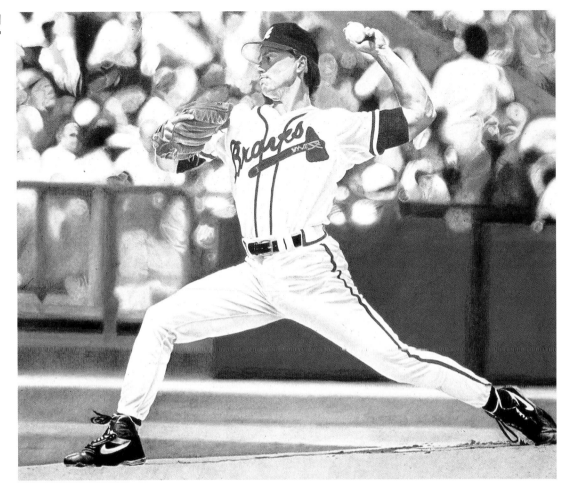

SUSAN WALSH
Mouths 17" x 27"

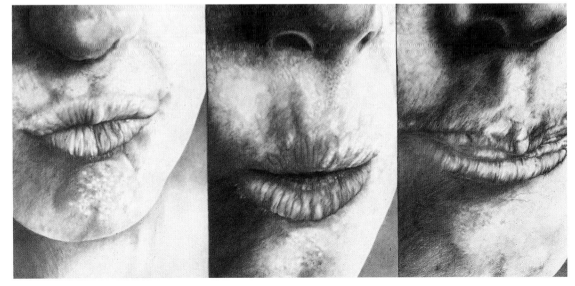

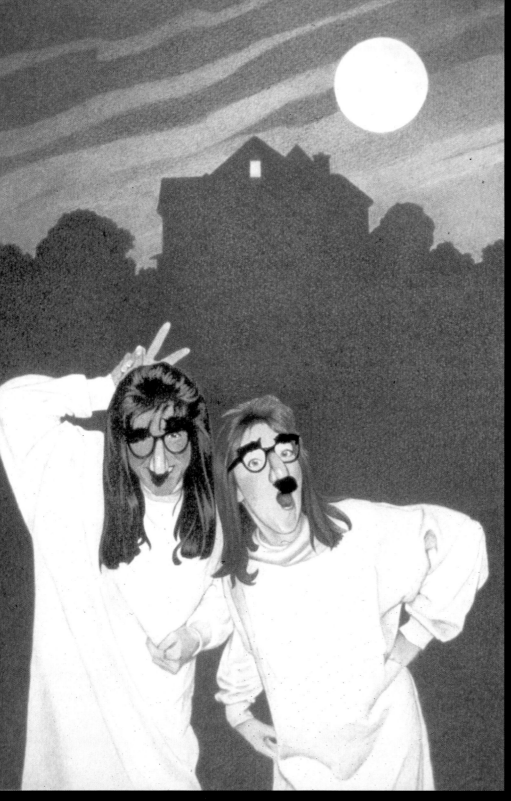

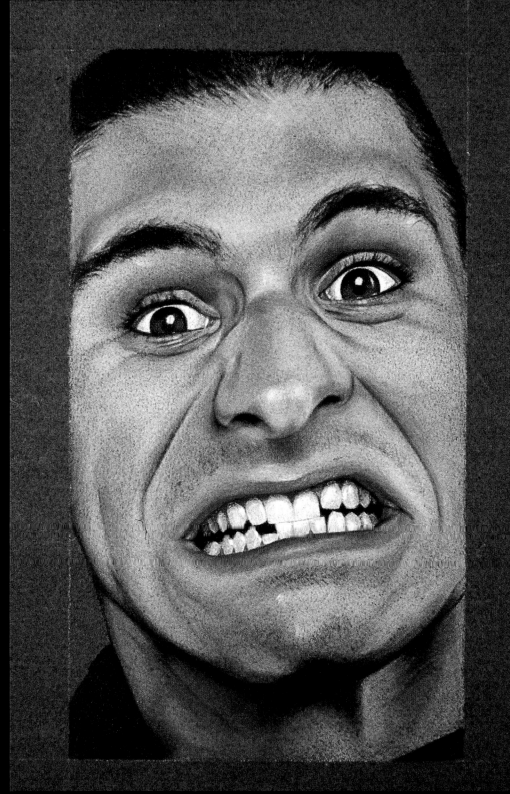

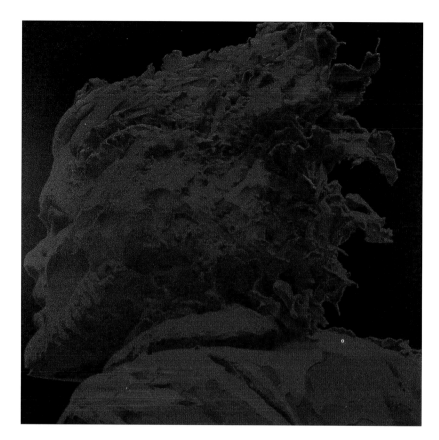

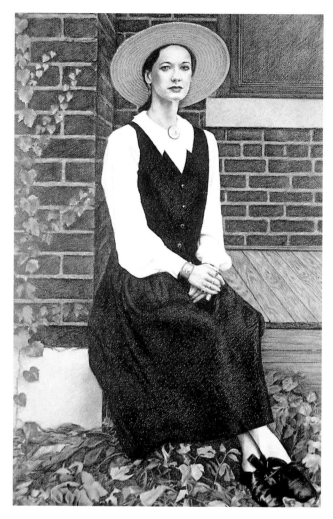

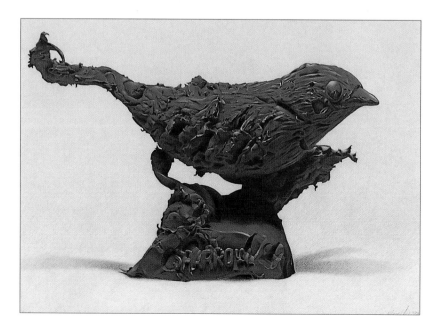

(counterclockwise from top left)

MIKE HILL
The Prophet 36" x 36"
Sparrow 14" x 20"

MARVIN TRIGUBA
Lady in Waiting 40" x 31"

48

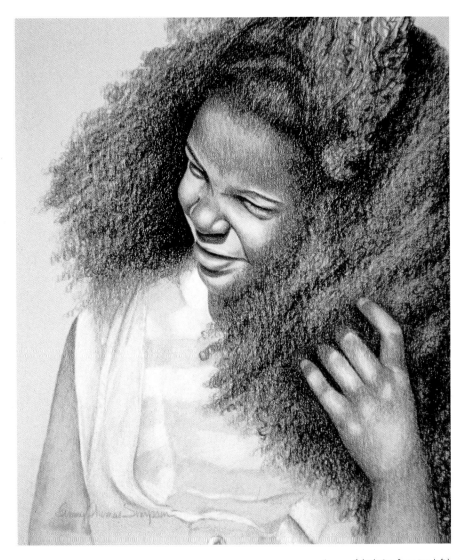

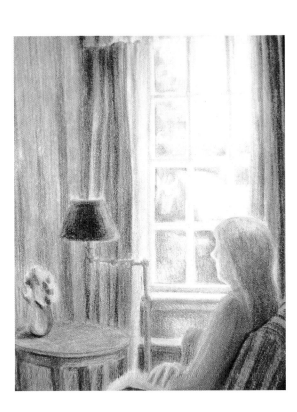

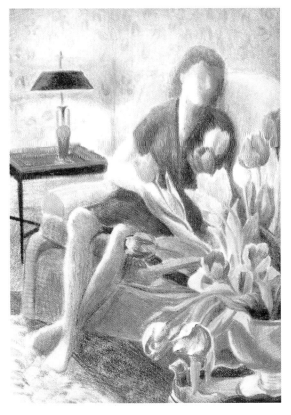

(clockwise from top left)

PENNY THOMAS SIMPSON
Tiara 22" x 20"

BRIGITA FUHRMANN
Morning Respite 12" x 10"
Catnip 10" x 8"

49

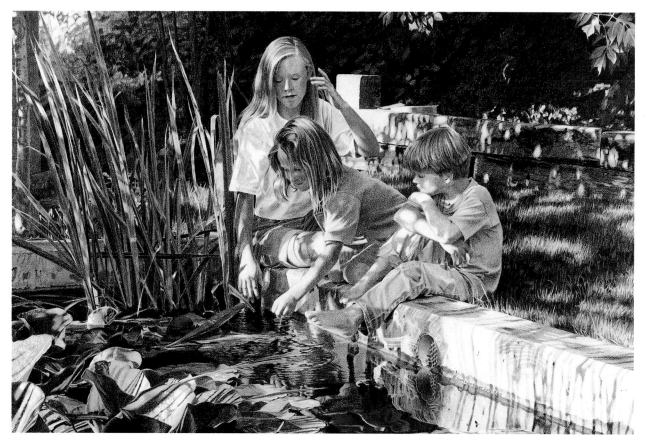

SHERI LYNN BOYER DOTY
Summer Afternoon

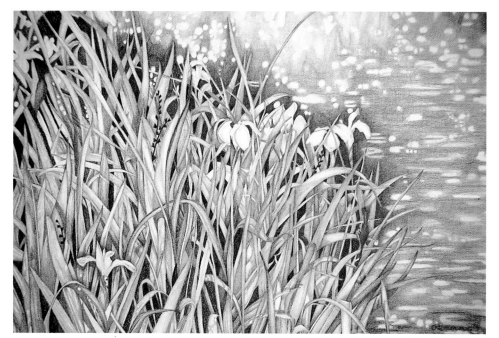

JAN RIMERMAN
Beth Chatto's Garden
33 ¹/₂" x 26"

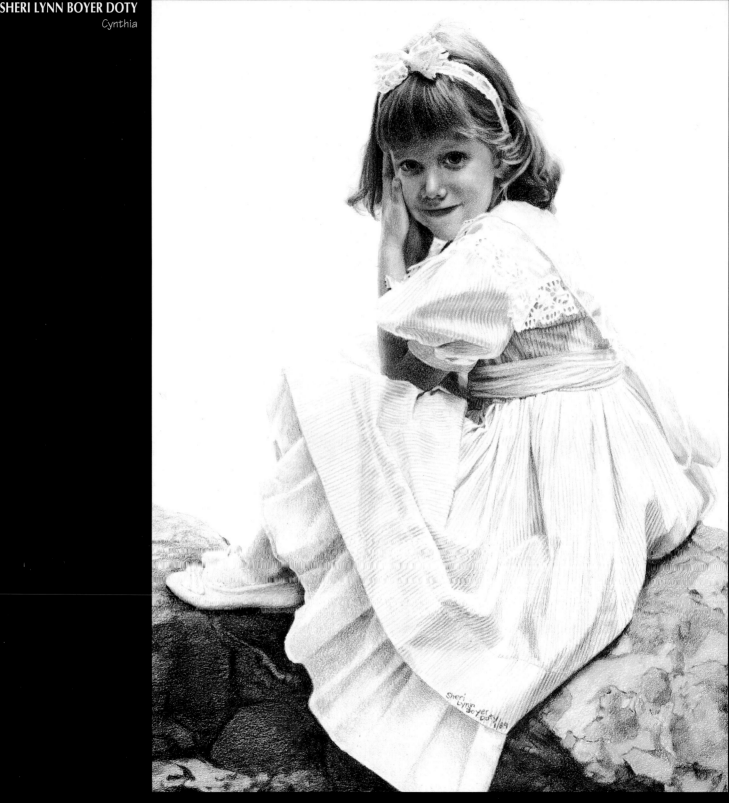

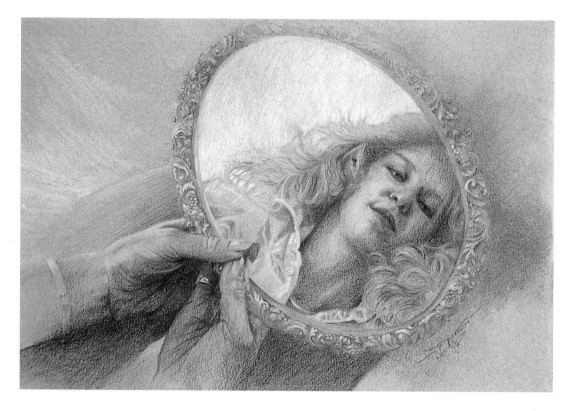

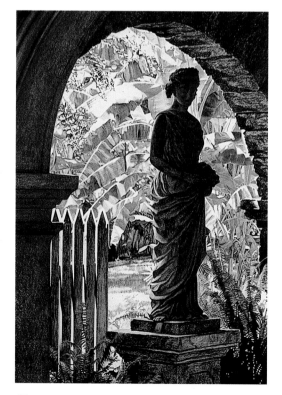

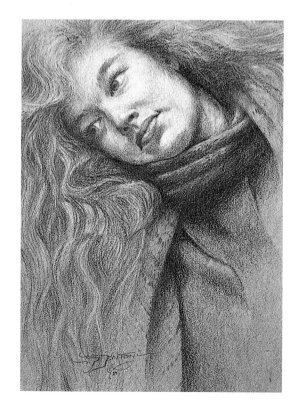

52

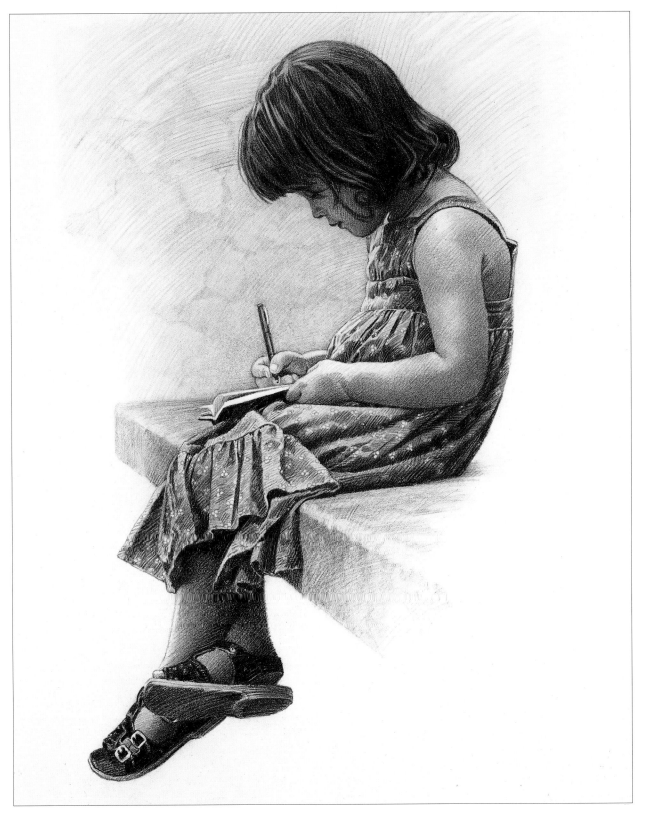

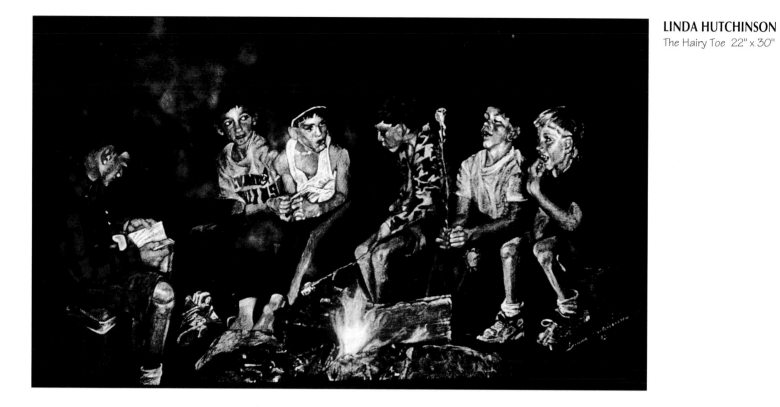

LINDA HUTCHINSON
The Hairy Toe 22" x 30"

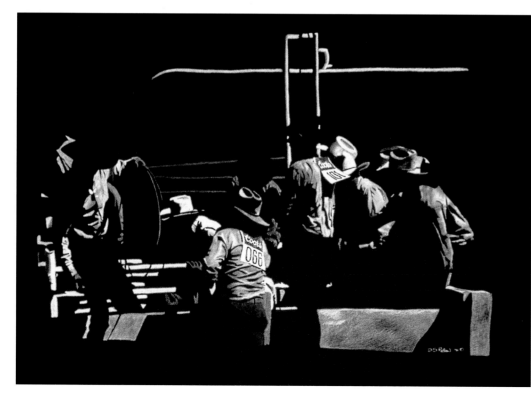

STEPHANIE S. PICARD
At the Chute 25 ½" x 31"

(clockwise from top)

RANDY McCAFFERTY
Jazz Trumpet 13 ½" x 25 ¾"
Louis Armstrong 16 ¾" x 9 ½"

ROBERT ZAVALA
Big City Jazz 16" x 12"

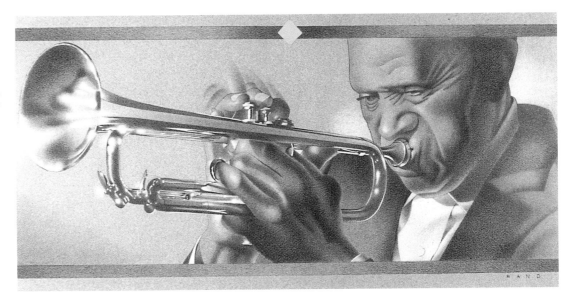

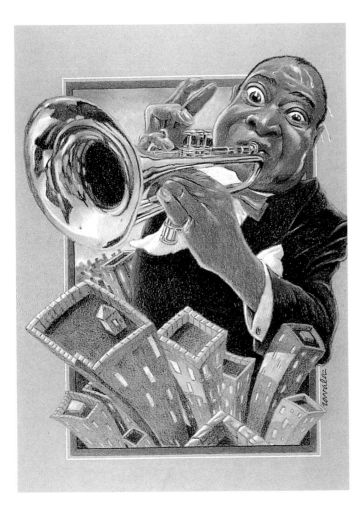

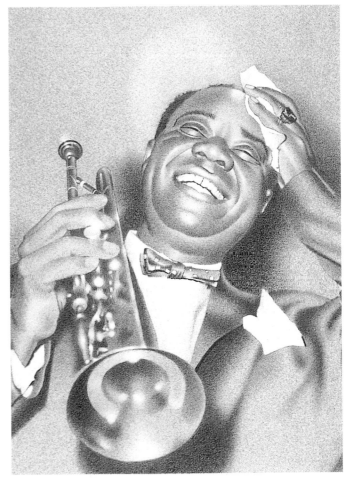

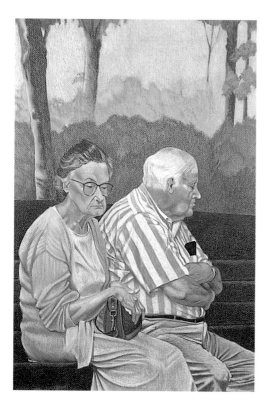

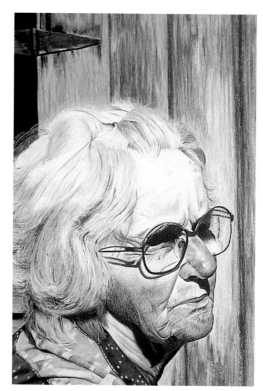

BONNIE D. AUTEN
Odd Couple 18" x 25"

DR. CHRIS DAVIS
Sarah 30" x 24"

DAVID JOHN THOMPSON
My Mom 23" x 29"

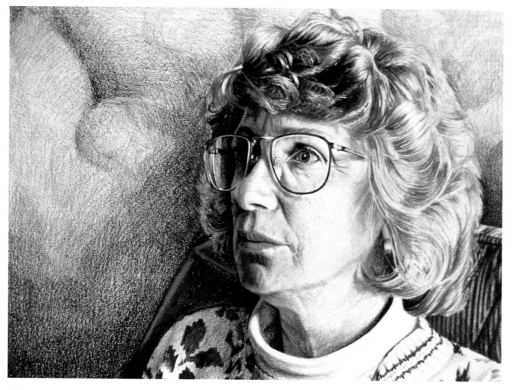

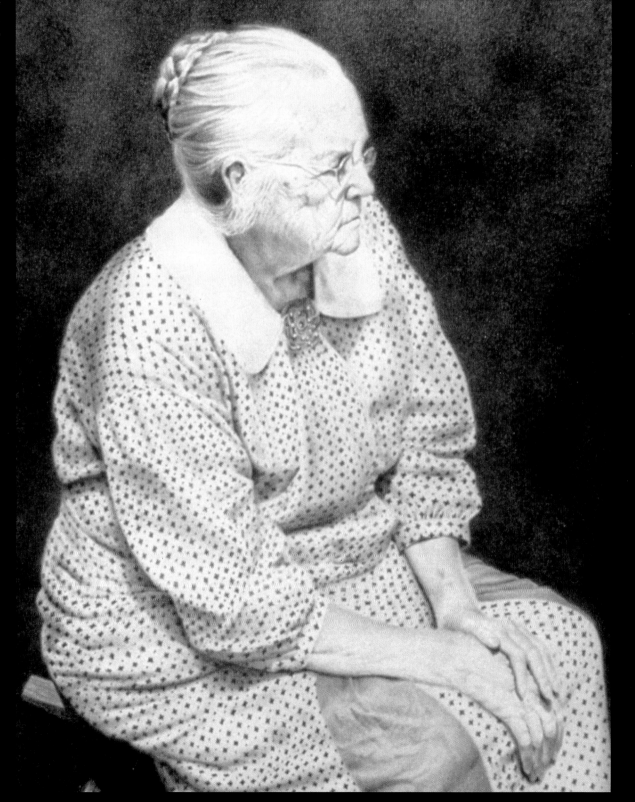

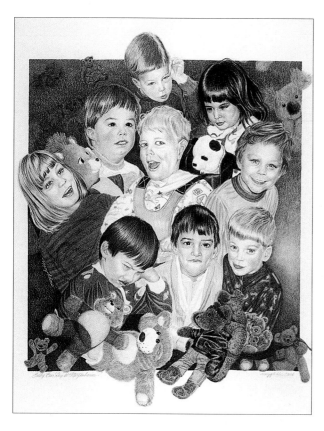

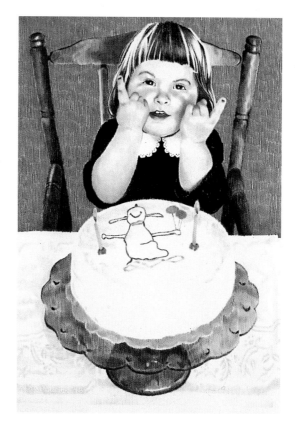

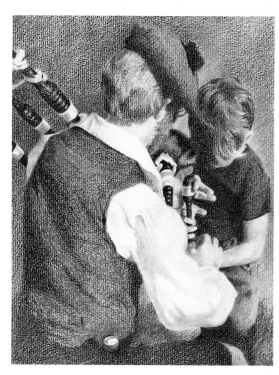

(clockwise from top left)

MARY HOBBS
Teddy Bear Day at Metzenbaum
26 ½" x 22"

BARBARA NEWTON
Two 13" x 9 ½"

PATRICIA JOY McVEY
First Lesson 11" x 8 ½"

CLAUDIA LOOMIS CHANDLER

Bump on a Log 26" x 37"

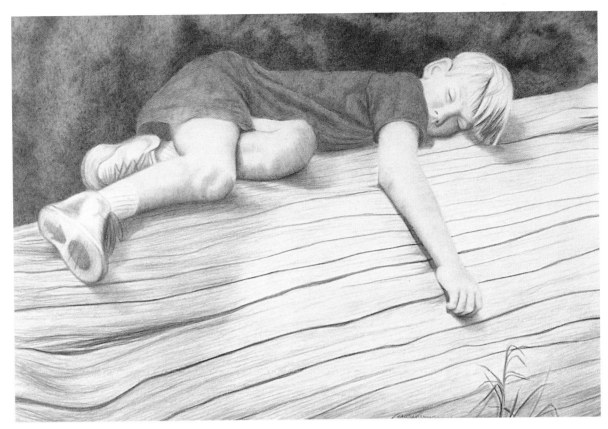

PHILLIP WILSON

Missy 21" x 37"

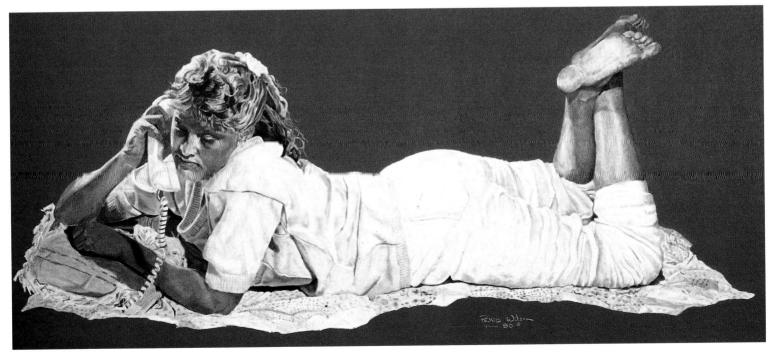

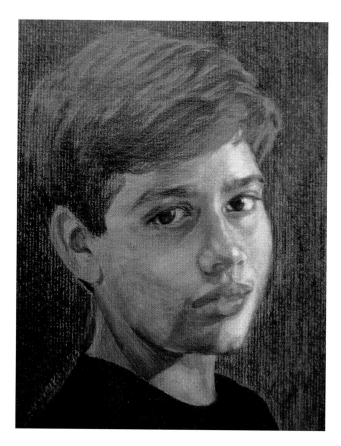

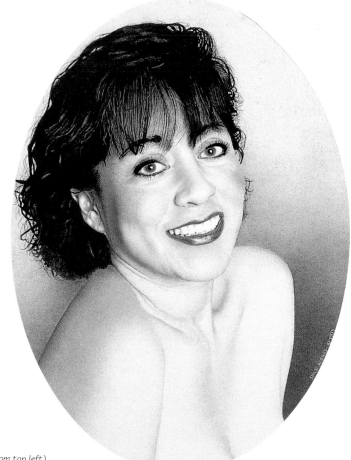

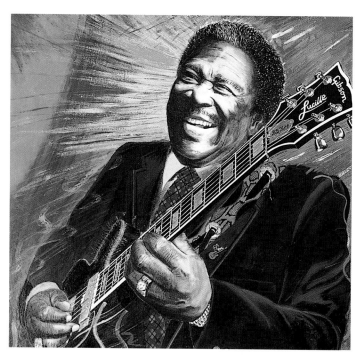

(clockwise from top left)

JANET C. WALKER
The Promise 10" x 8"

DAVE KOENIG
Windows of the Soul 16" x 20"

JIM COWEN
BB King World Tour 16" x 15"

(clockwise from top)
CELINE GRATTON
Chrysalis 21" x 29"

BILL REICHARDT
Untitled 28" x 32"
Mercy 30" x 30"

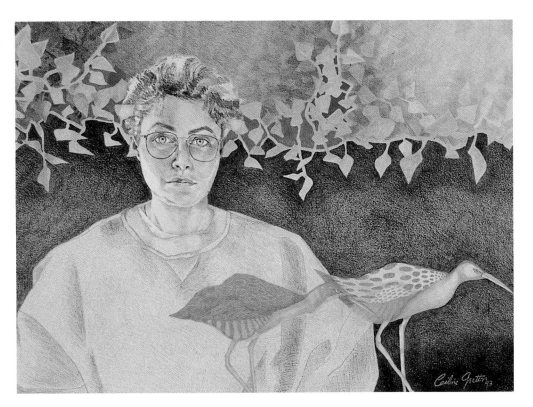

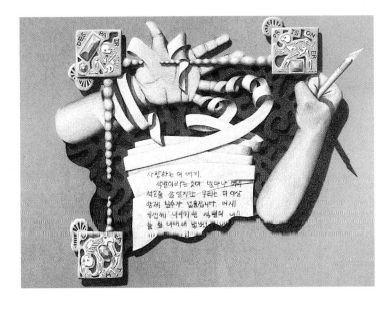

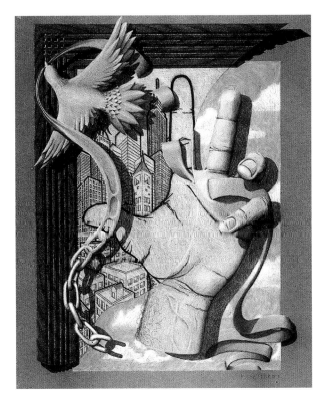

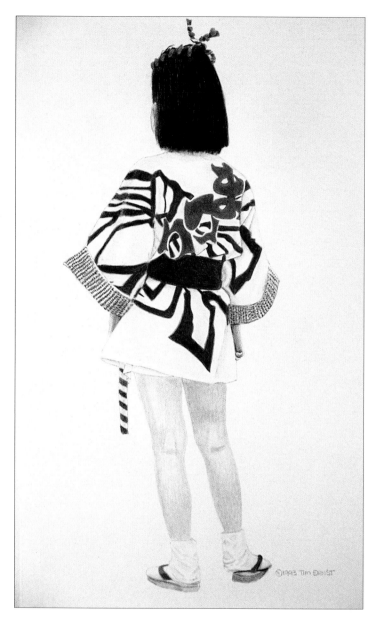

TIM ERNST
The Festival Dancer 14" x 10 ½"

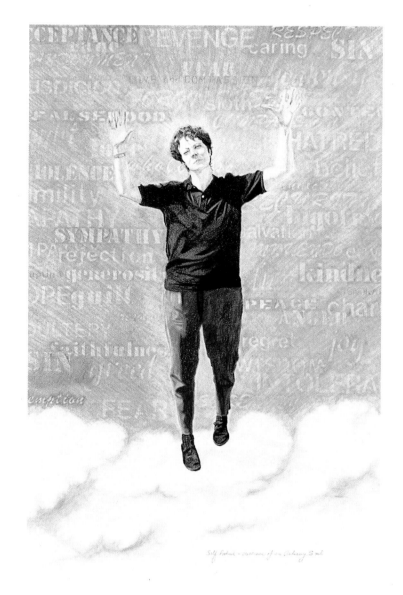

CHERIE L. LACY
Self Portrait-Ascension of an Ordinary Soul
35" x 27"

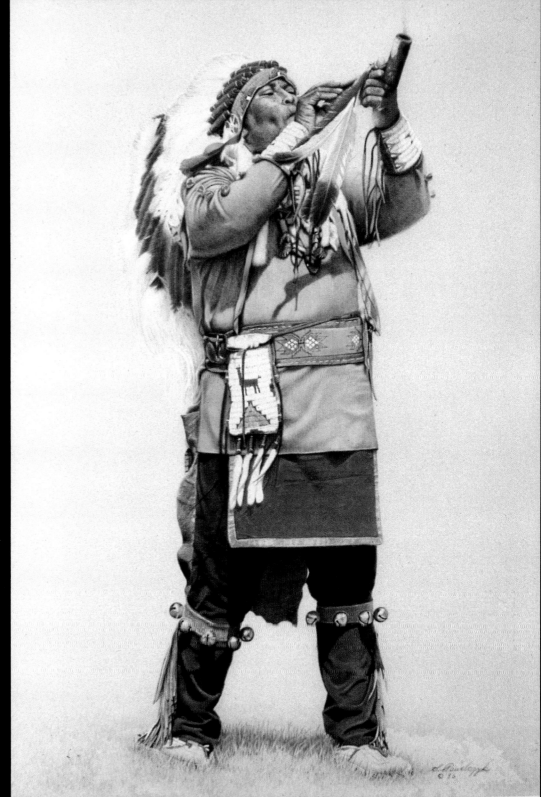

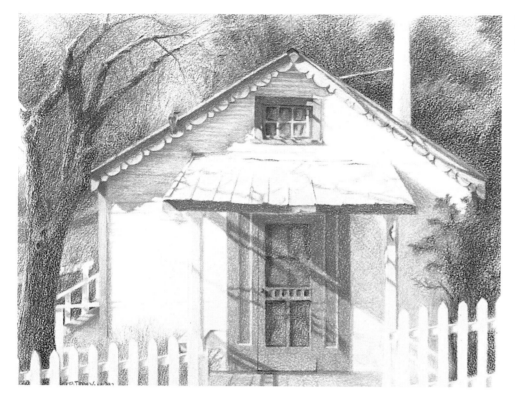

PATRICIA JOY McVEY
Jay and School, Dutch Flat
11" x 15"

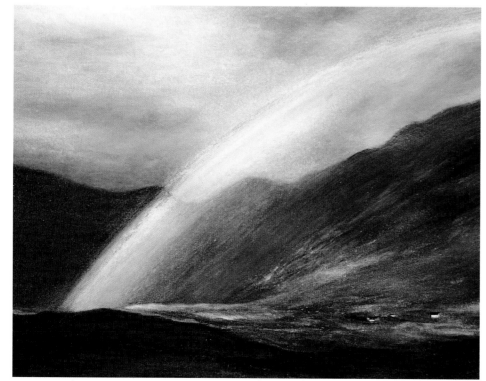

PAT STOLTE
Irish Rainbow 16" x 20"

JANET LOUVAU HOLT
Yellow Path 24" x 28"

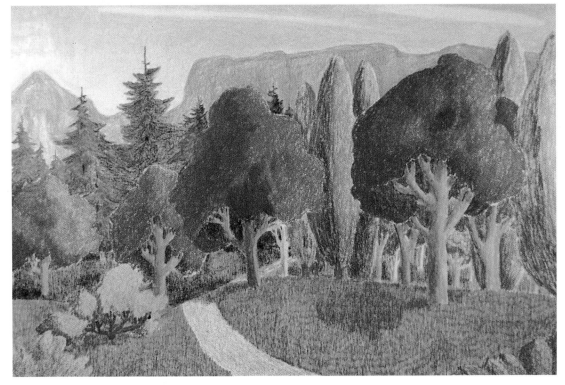

VIRGINIA H. BARBER
Pilgrim Hikes the "Garden Wall"
16" x 21 ¼"

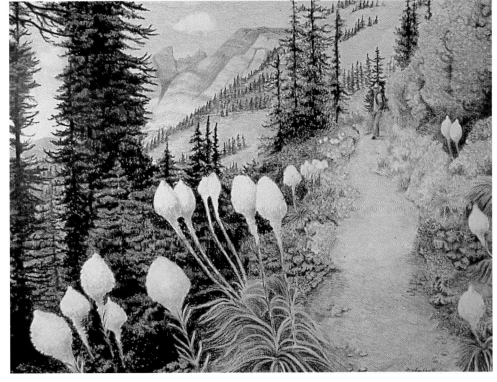

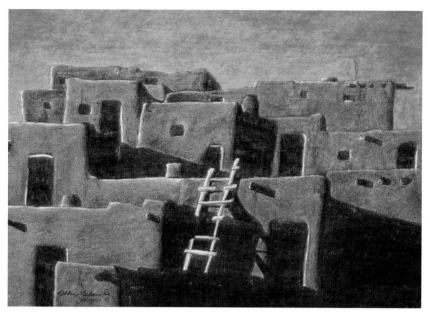

ROBBIN BELOUS NEFF
Taos Gold 6 ³/₄" x 9 ³/₁₆"

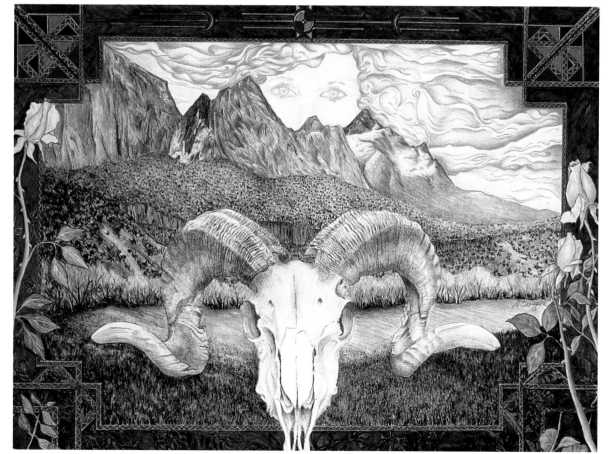

ALEX GRAHAM
Salvation Lies Within
Her Eyes 29" x 36"

VIRGINIA FINN
Attic II *(above)* 25" x 44"
Past, Present, Future
(below) 19" x 40"

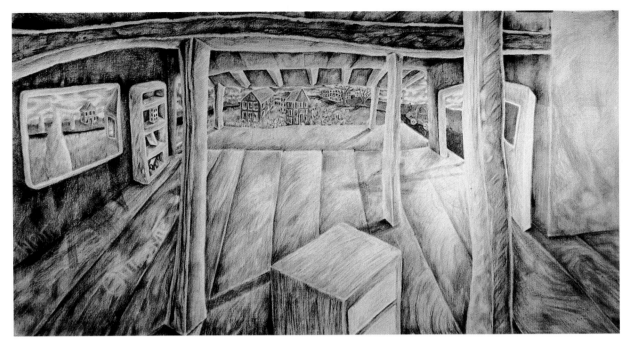

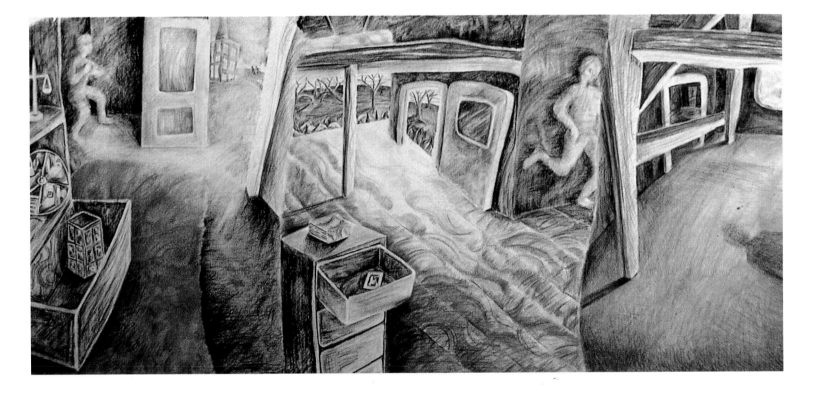

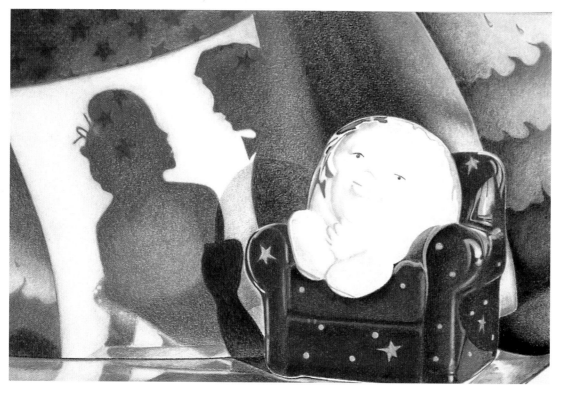

ROBYN EHRLICH
Blue 9 ¼" x 14"

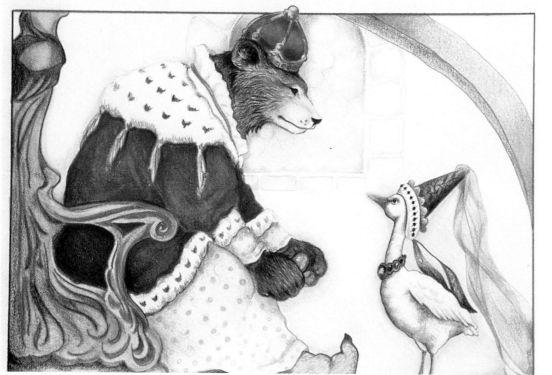

WAYNE SPECTOR
The Bear King 7" x 10"

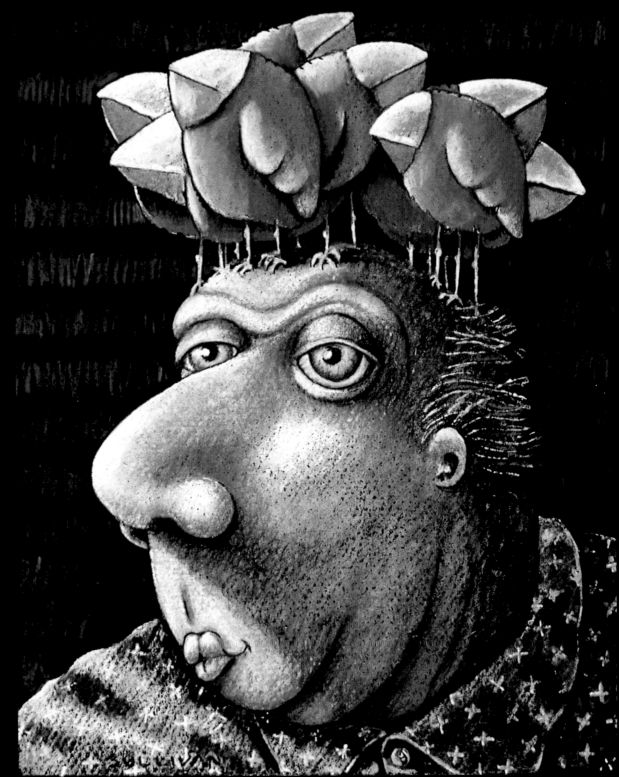

DON SULLIVAN
Seven Blind Birds
10" x 6"

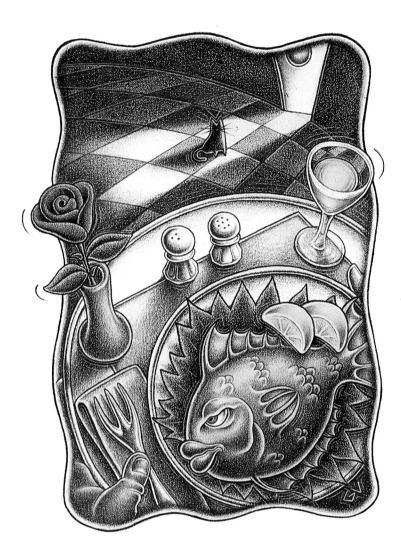

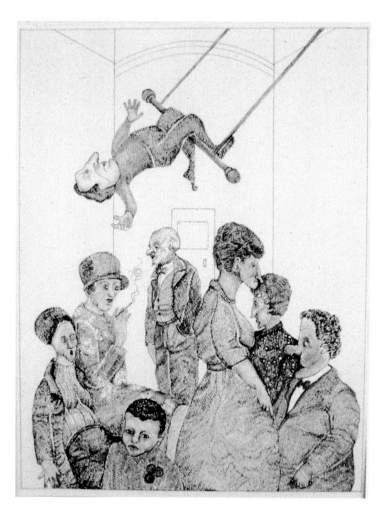

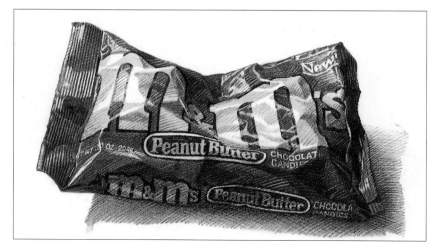

(clockwise from top left)

GREGG VALLEY
Fish Dinner 14" x 11"

GWEN DIETRICH
Subway 23" x 18"

LINDA FENNIMORE
M & M's

PATTI GLOSS
Secret Garden 13" x 9"

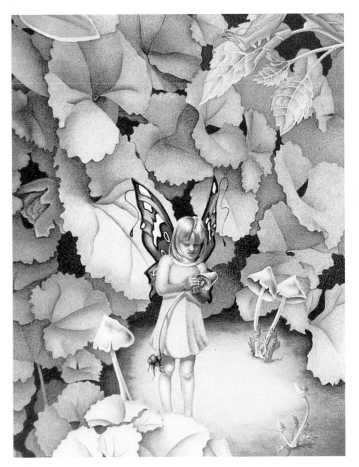

BOB VARGO
Floral Flight 6 ¹/₄" x 10 ¹/₂"

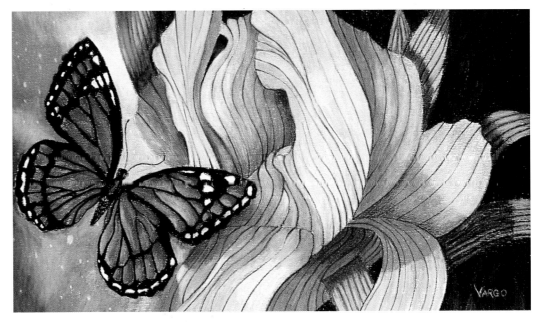

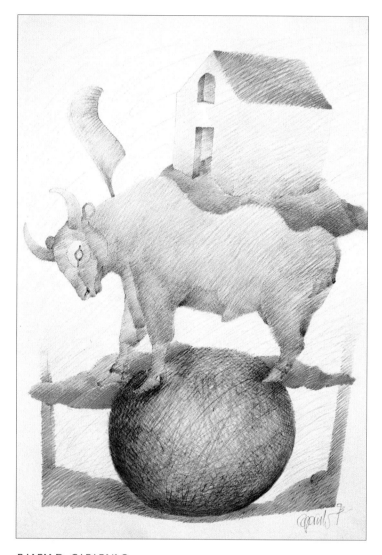
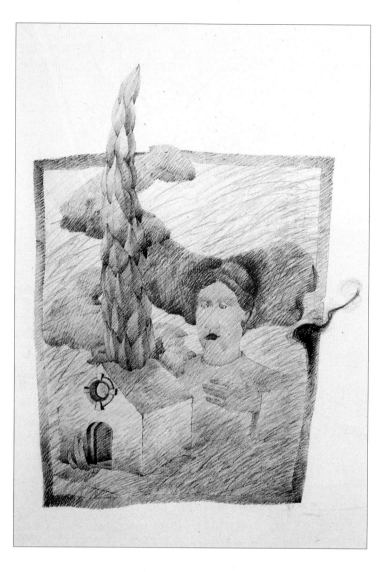

RALPH D. CAPARULO

The Bull of Kakam *(left)* 26" x 19"
The Temple of St. Asparagus *(right)* 29" x 23"

VERA CURNOW
House of Preyers 30" x 40"

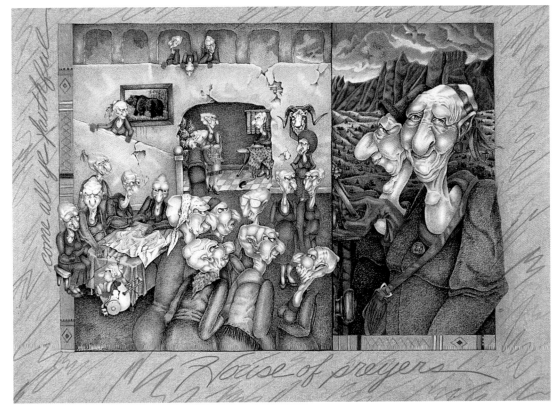

NANCY C. KESSEL
It's Not a Game 31" x 39"

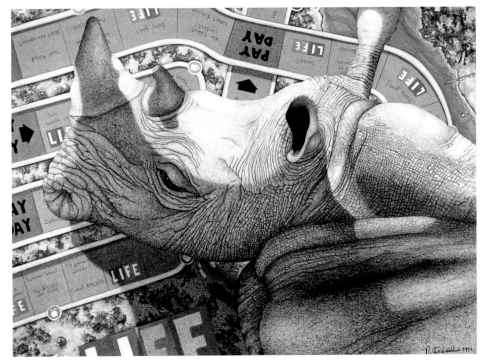

GARY GREENE
Candles 26" x 36"
Empire Berol USA Award

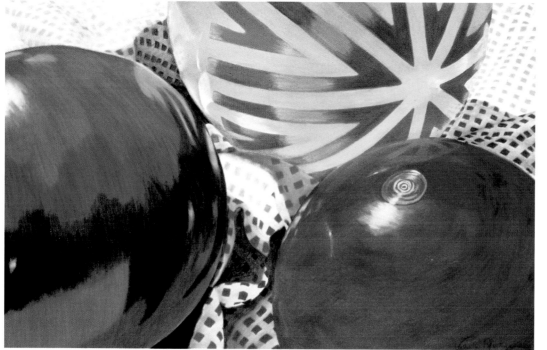

VALERIE RHATIGAN
Reflection in Color I
24 ½" x 34"

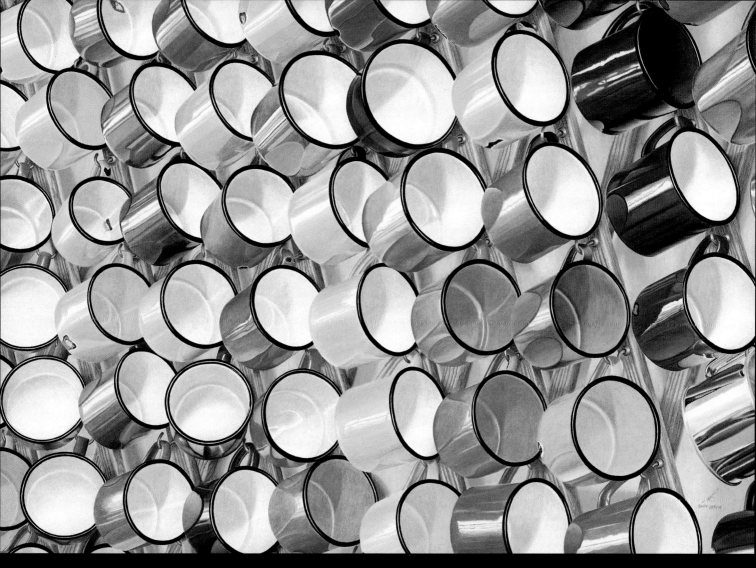

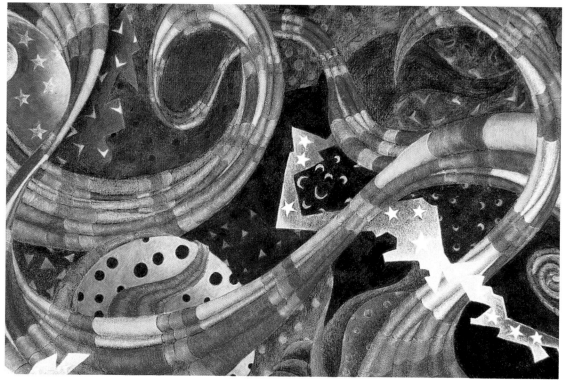

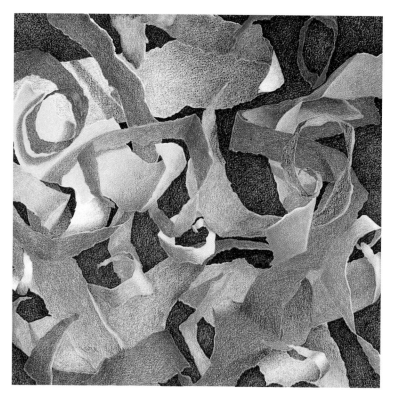

JANE WILLIS
Chromatic Tangle 22" x 22"

LULA MAE BLOCTON
Untitled 29" x 39"
Derwent Pencil
Award of Excellence

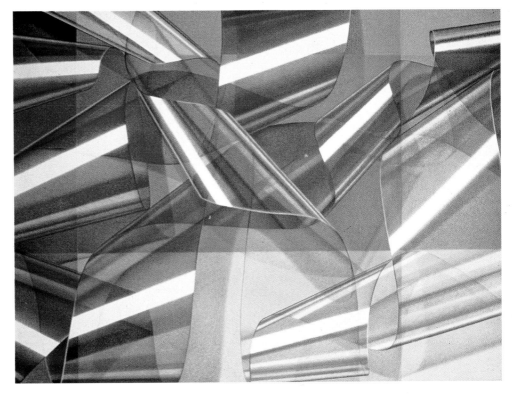

VALERIE RHATIGAN
Reflection in Color II 24 ¹/₂" x 34"

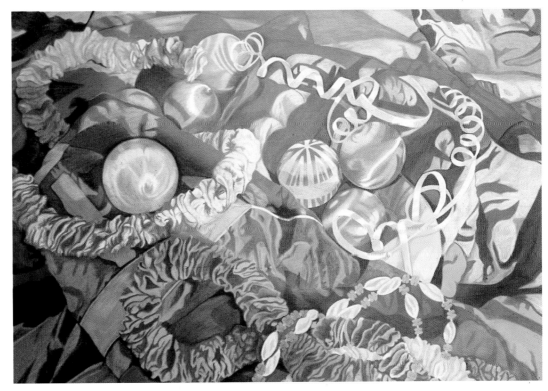

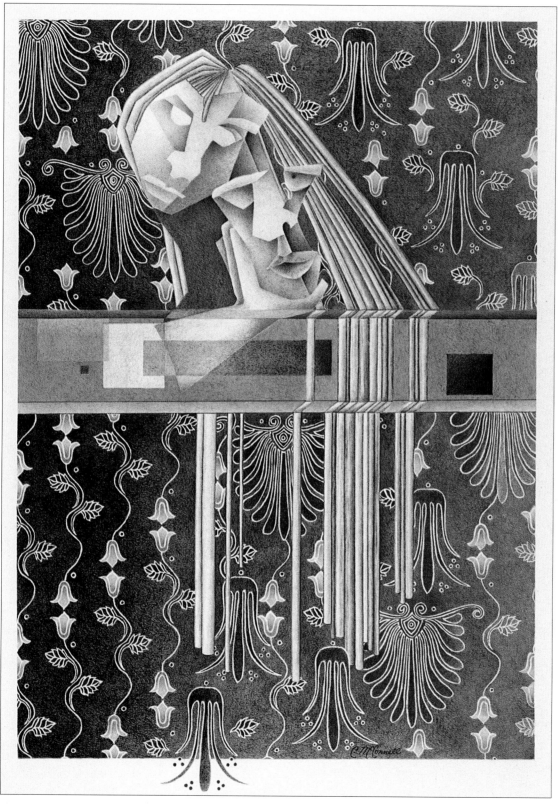

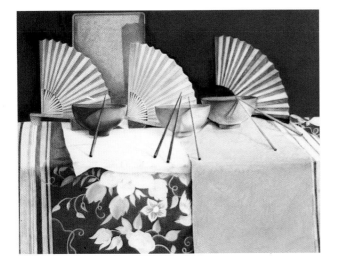

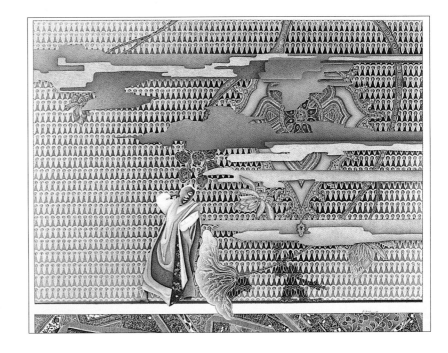

(clockwise from top left)
RITA LUDDEN
Three Fans 21" x 27"

CARLA McCONNELL
African Skies 32" x 40"

SHARON TEABO
To Each His Own 18" x 24"

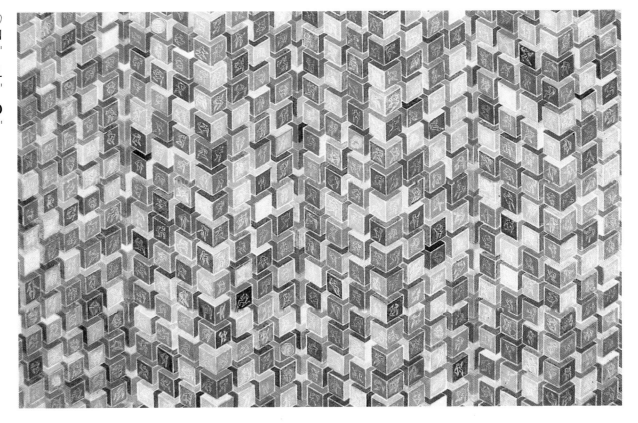

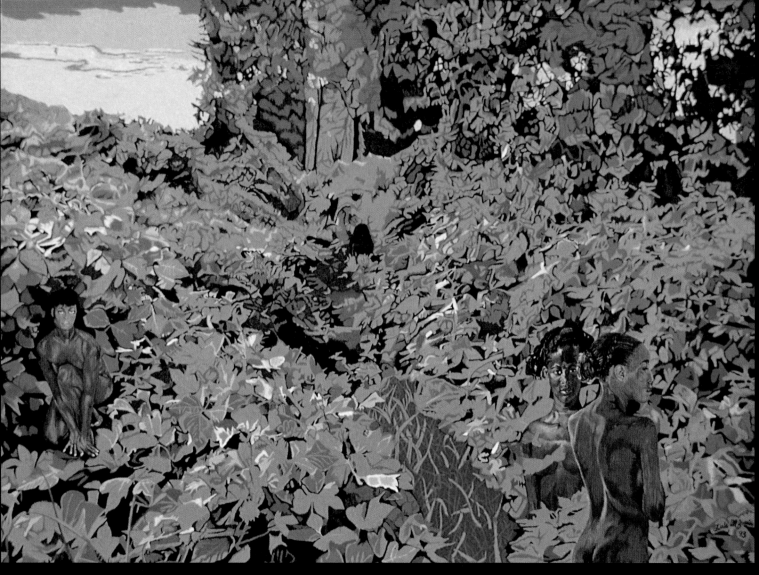

DALE M. BONIN
Foot-a-Nite, Tired of Green 22" x 30"

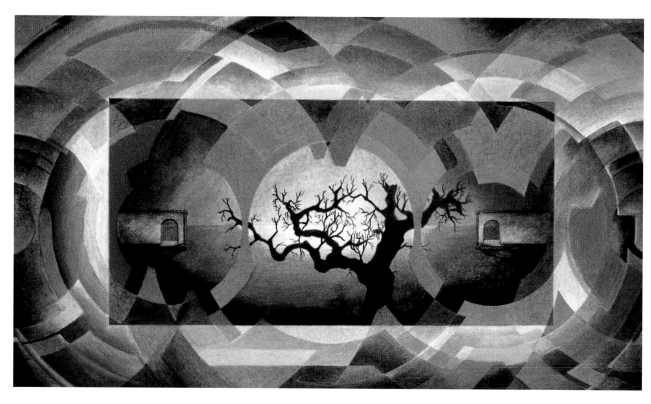

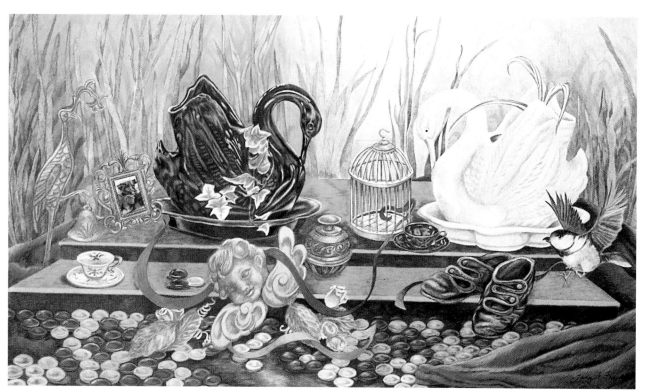

JUDY A. FREIDEL
Steps & Pieces
22" x 32 ½"

82

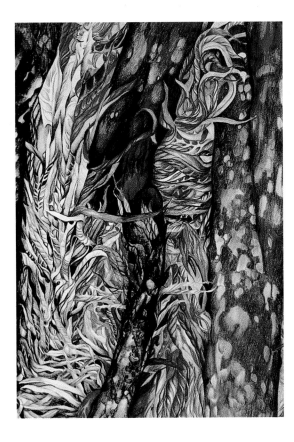

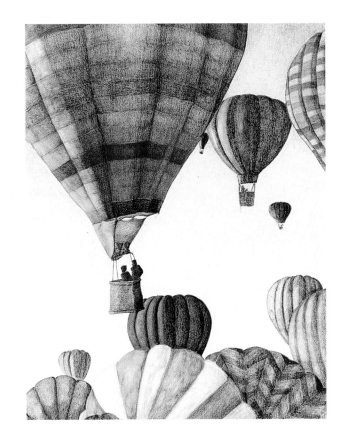

(clockwise from top left)
CHRISTINE FUSCO
A Provocative Encounter 32" x 25"

ELISABETH MILES-NEELY
Uprising at Dawn 26 ¼" x 20 ¼"

TIMOTHY SANTOIRRE
Somewhere Between Black and White
11" x 9"

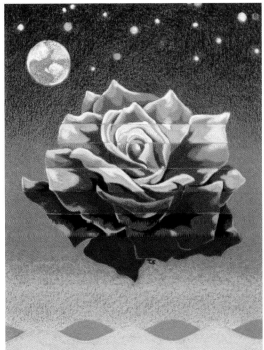

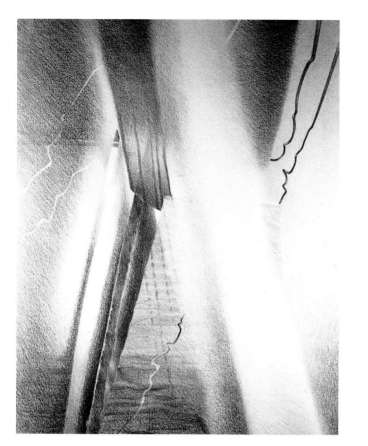

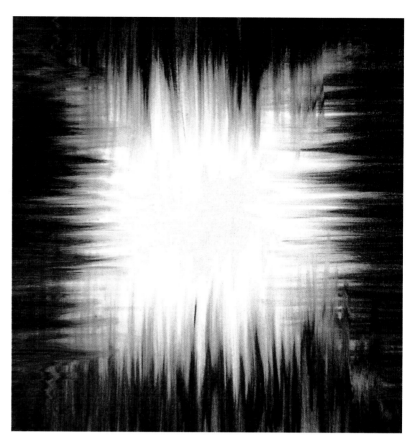

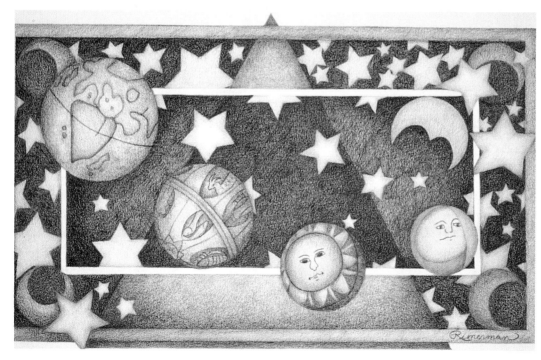

(clockwise from top left)

GRETCHEN MARICAK
Zoomorph Abstract 102 28" x 22"

DARA MARK
Storm Clearing #2 16" x 16"

JAN RIMERMAN
And Every Night of the World 24 ½" x 23 ½"

GREGORY S. McLELLAN

A Man Torn (Altered) (above) 7" x 8 ½"
A Man Torn (Again!) (below) 9 ½" x 12 ½"

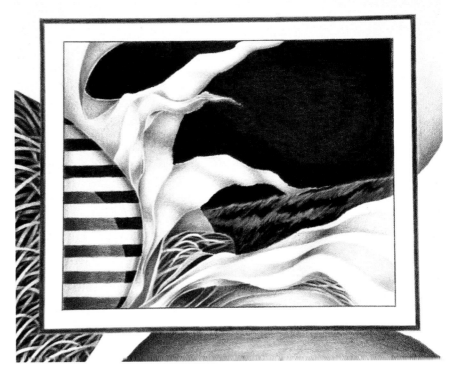

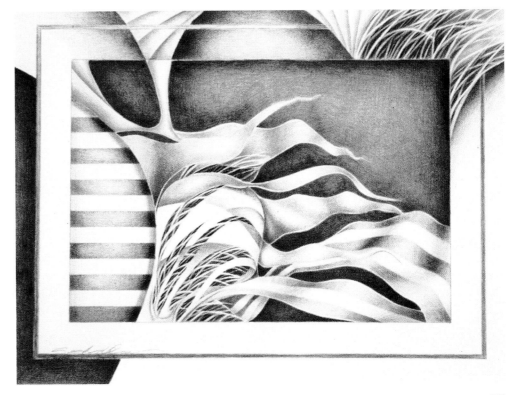

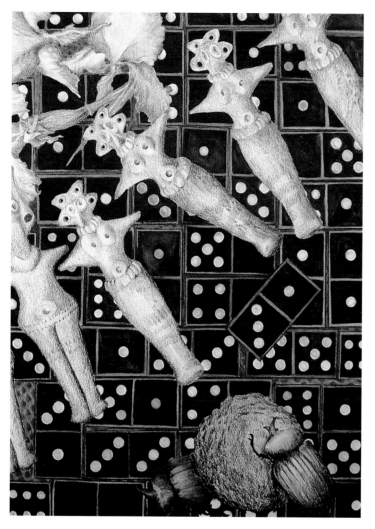

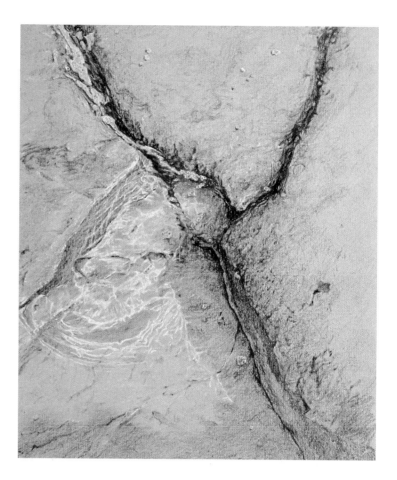

(clockwise from top left)
MICHAEL TEAGUE
Dominoe Fetish 24" x 18"

DANIEL C. DEMPSTER
Filament 19" x 16"
Prospero's Pool 16" x 19"

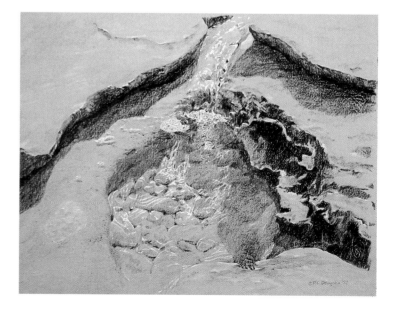

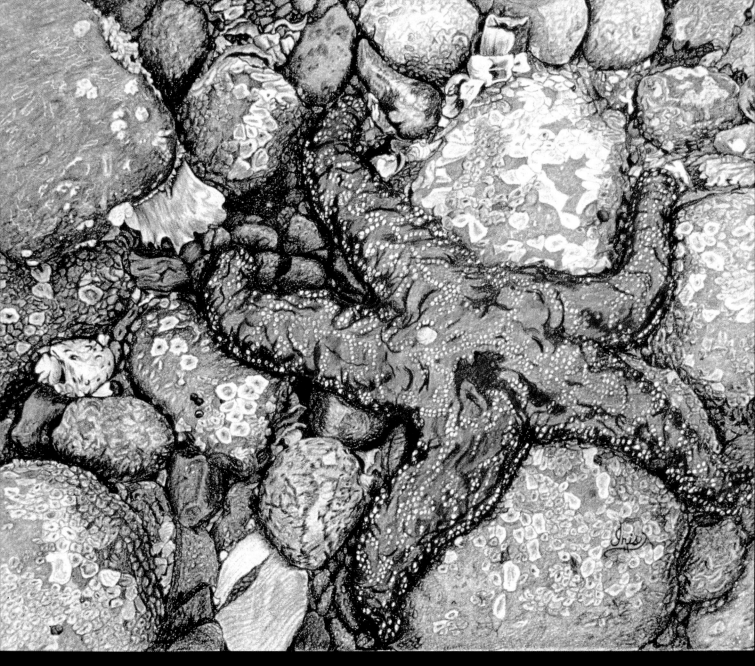

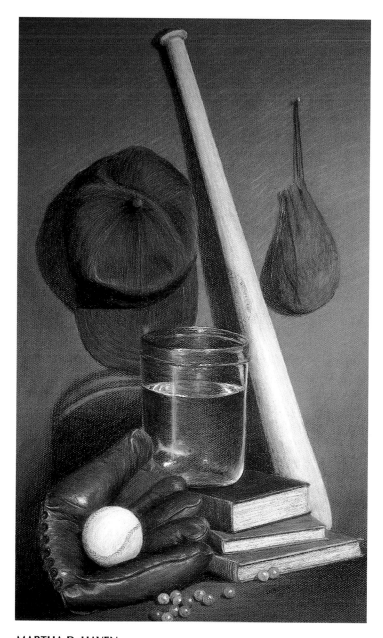

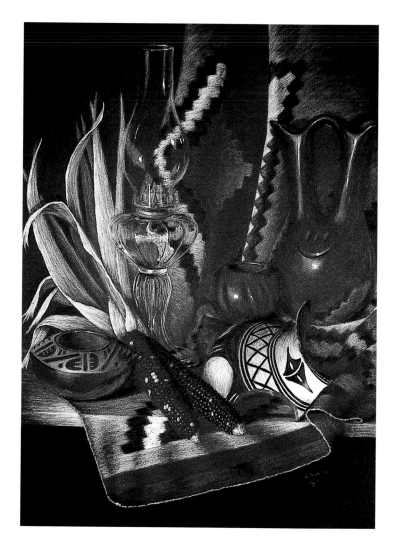

MARTHA DeHAVEN
Yesterday's Treasures *(left)* 16" x 27"
Heritage *(right)* 28" x 22"

ROBYN EHRILCH
Vermilion 19 ½" x 14 ½"

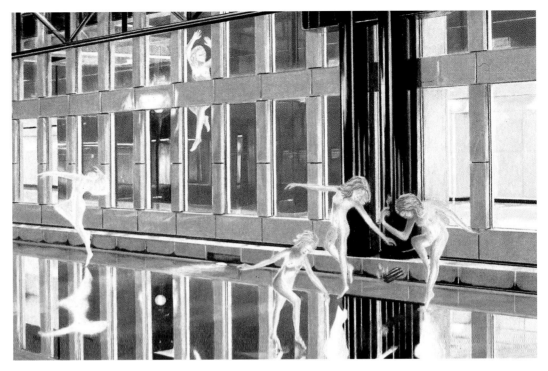

MELISSA MILLER NECE
Night Neon II (No Vacancy)
19" x 26"
Artistic Merit Award

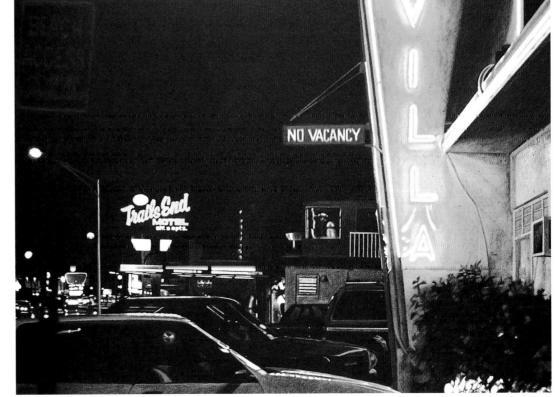

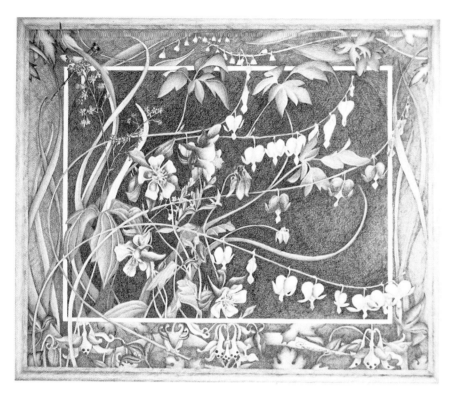

JAN RIMERMAN
For You My Heart and Soul
31 ½" x 34"

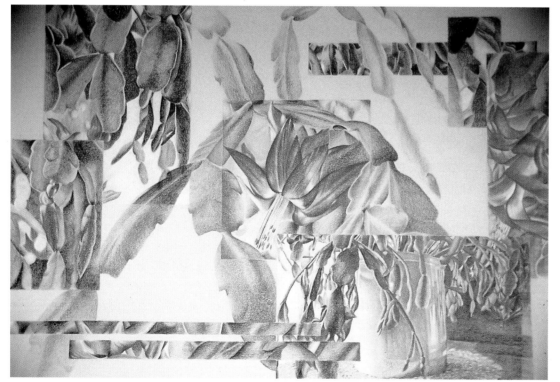

PRISCILLA HEUSSNER
December Oasis 31" x 39"

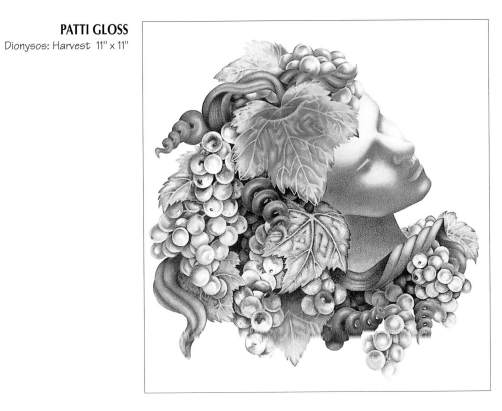

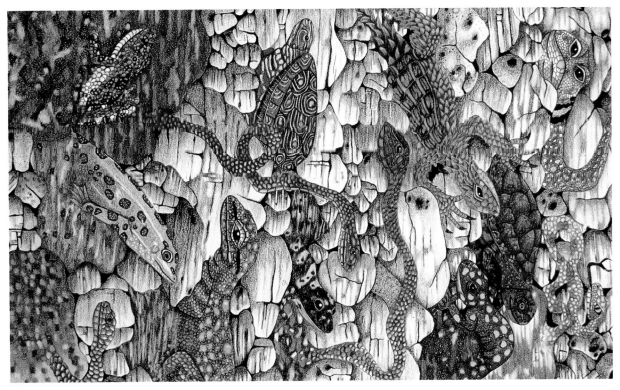

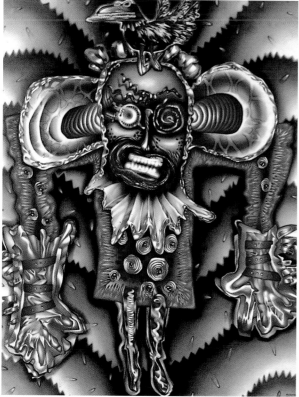

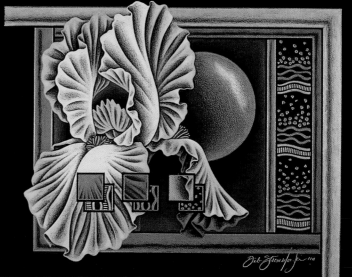

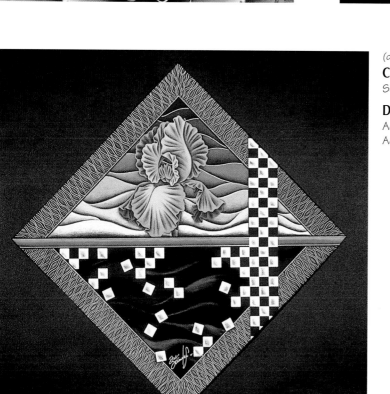

CHUCK RICHARDS
Scarecrow 40" x 32"

DEBORAH STROMSDORFER
Aqua Iris with Border Design 22" x 27"
Aqua Iris with Floating Checks 25" x 25"

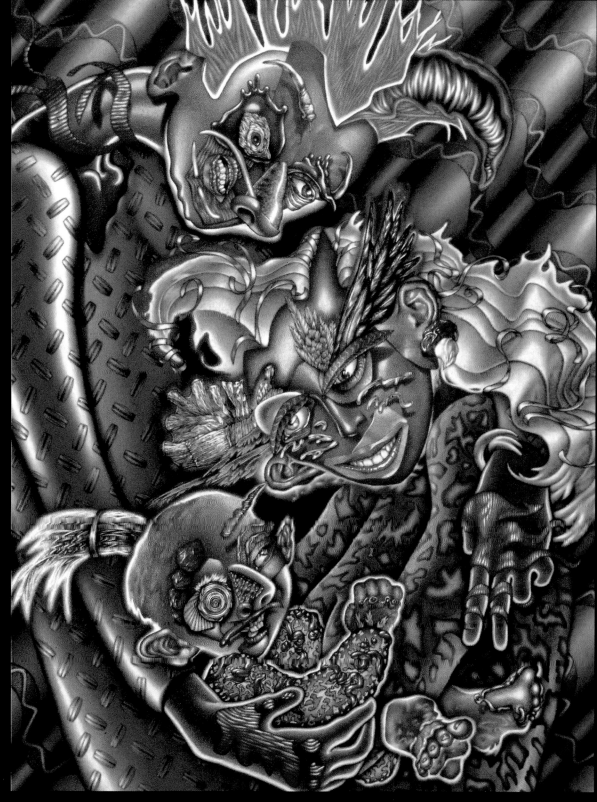

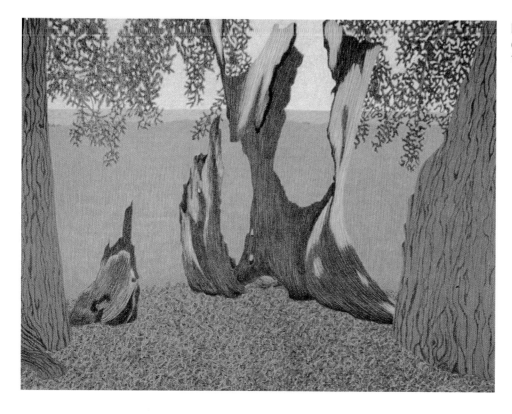

KATHERINE McKAY
Coast No. 1: Redwood Grove
19" x 25"

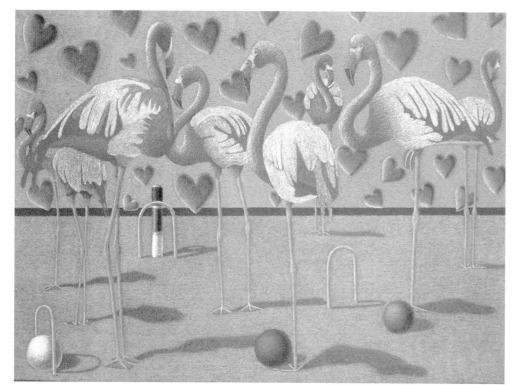

SHARON DI GIACINTO
Sunday Croquet Game
16" x 22"

94

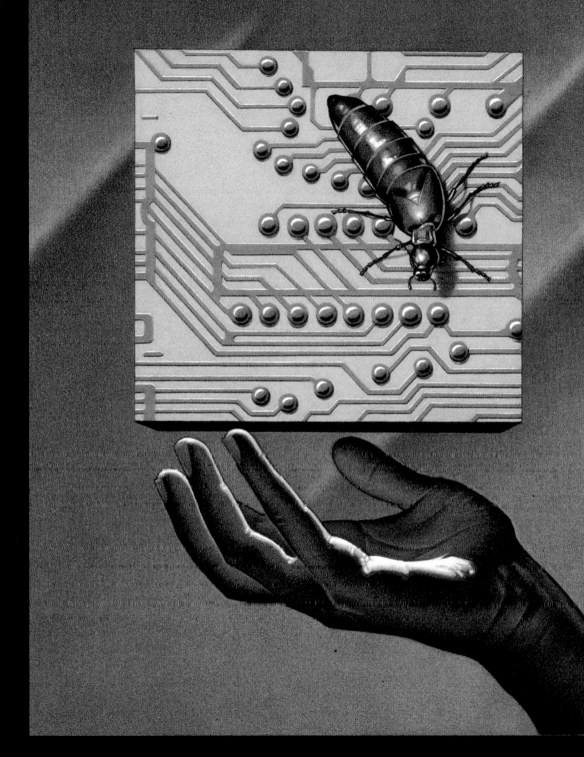

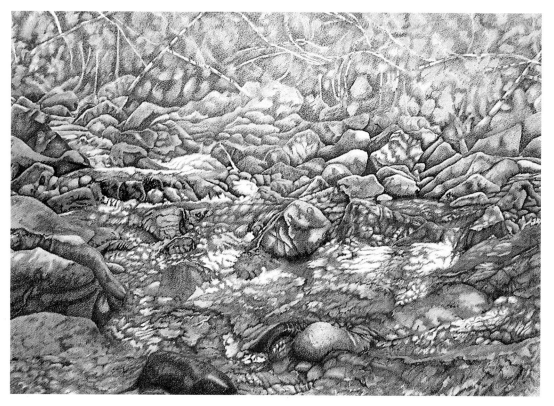

BLYTHE HOLT
A Journey Through Fall
16 ¼" x 24"

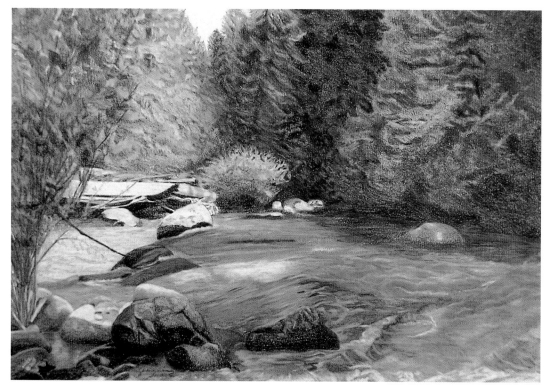

JEANNINE R. SWARTS
Powder River 12" x 18"

DALE M. BONIN
Paradise Rented 22" x 28"

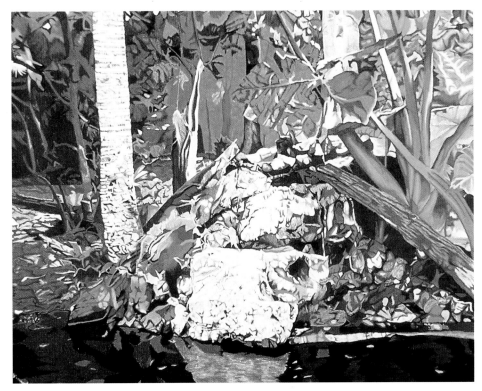

TERESA McNEIL MacLEAN
You Can Cross Here 10 ½" x 13 ½"

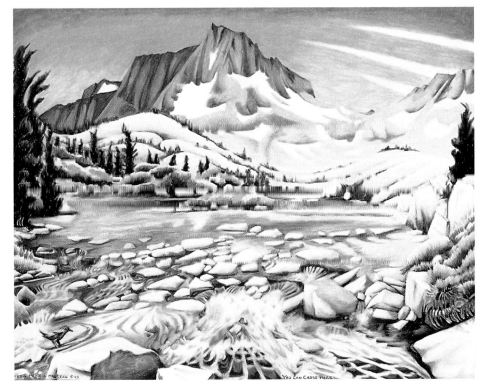

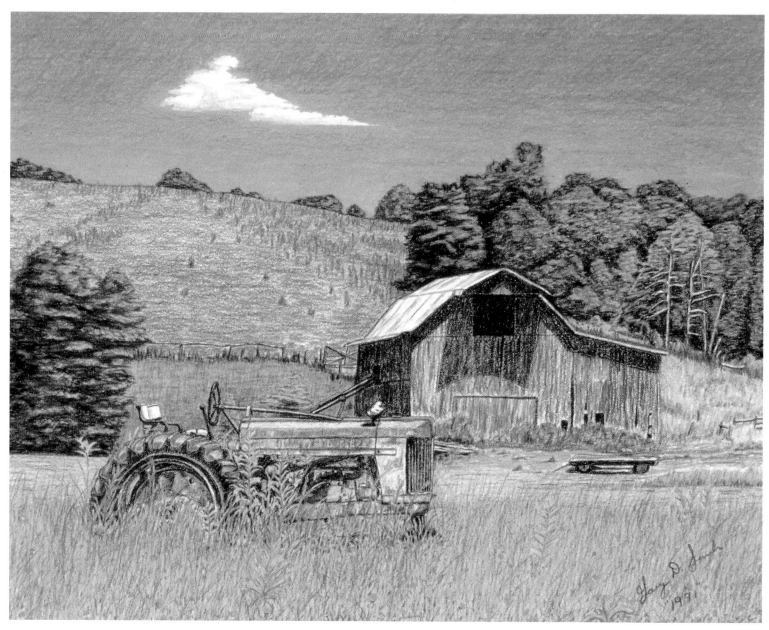

GARY D. SAULS
Buckeye Farm
10 1/4" x 13 1/4"

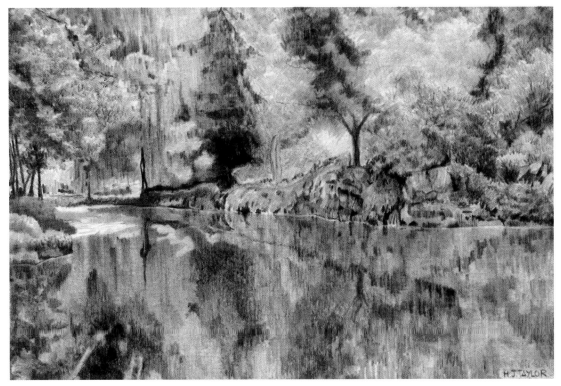

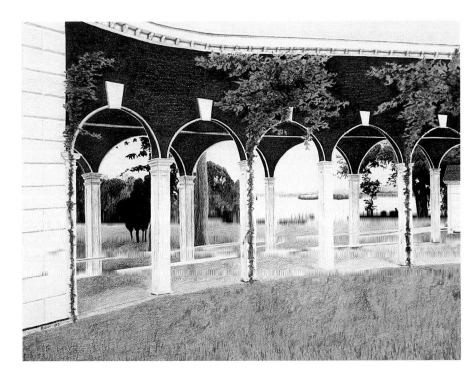

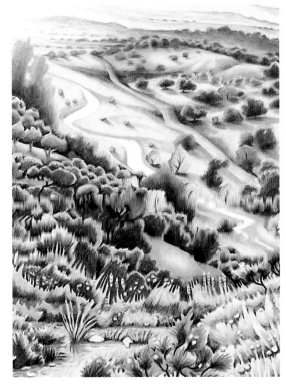

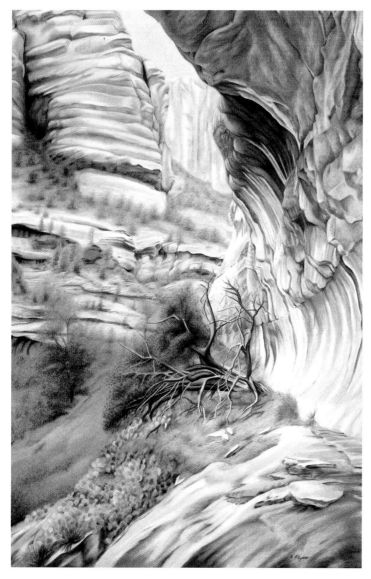

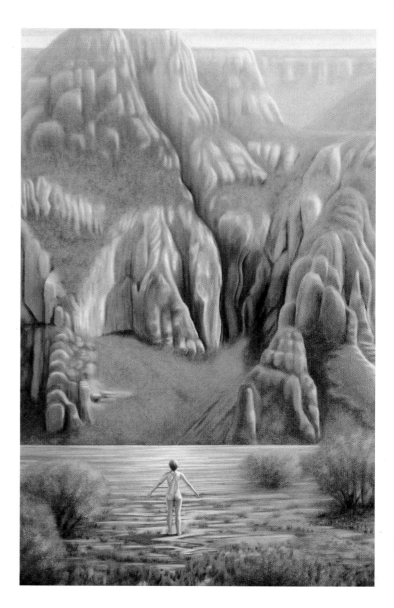

KATHARINE FLYNN
Refuge *(left)* 30" x 20"
Inner Child *(right)* 30" x 20"

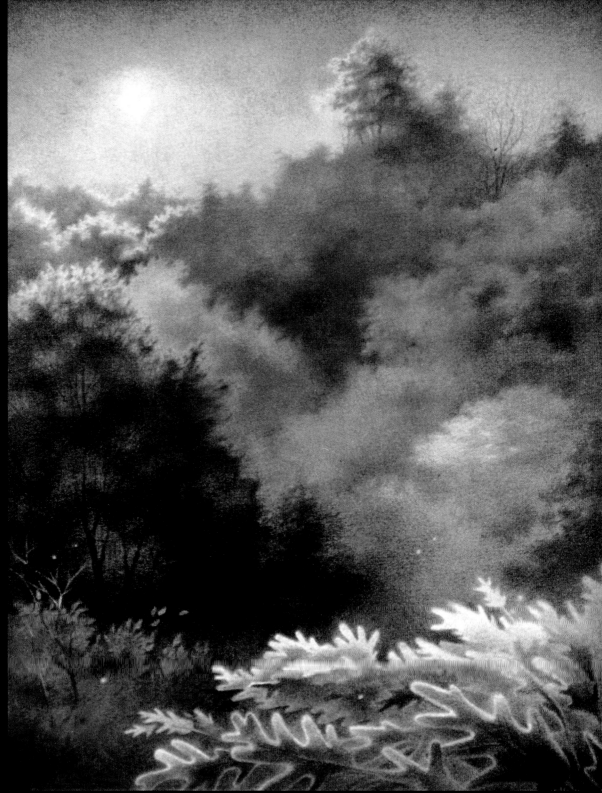

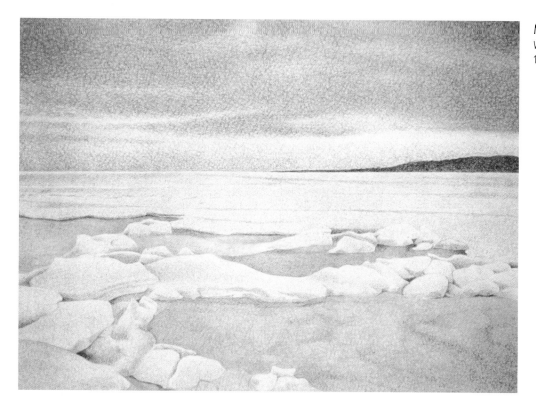

MICHAEL PETRINGA
Wellfleet Harbour
11 ¹/₂" x 16"

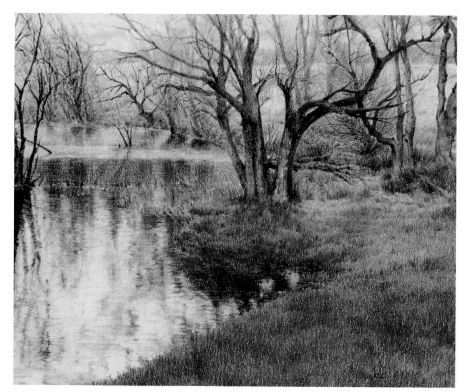

PAT AVERILL
A Fresh Hello
15 ¹/₂" x 19 ¹/₂"

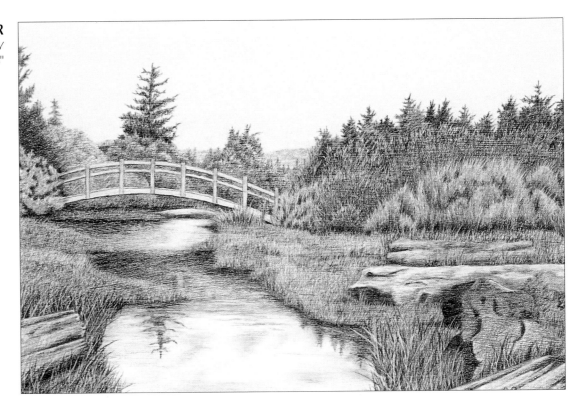

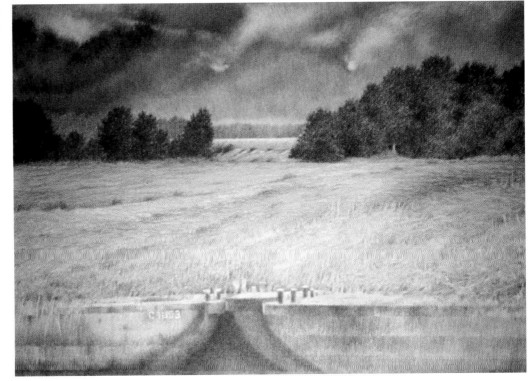

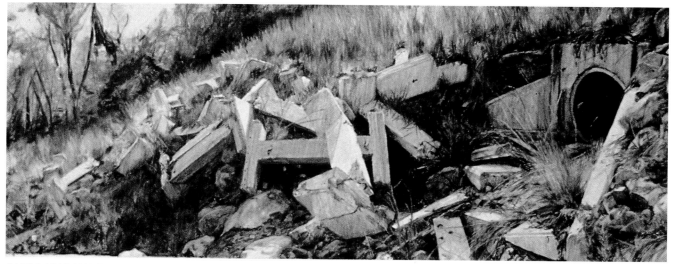

PAULA MADAWICK
Transition 13" x 23"

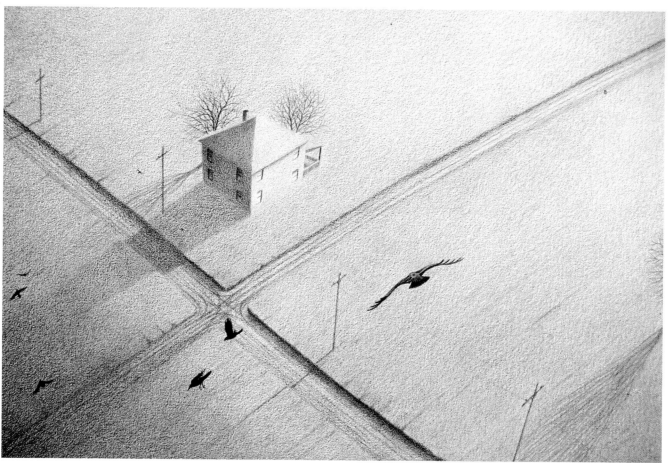

ALLAN SERVOSS
Freefall 18 ½" x 28 ½"

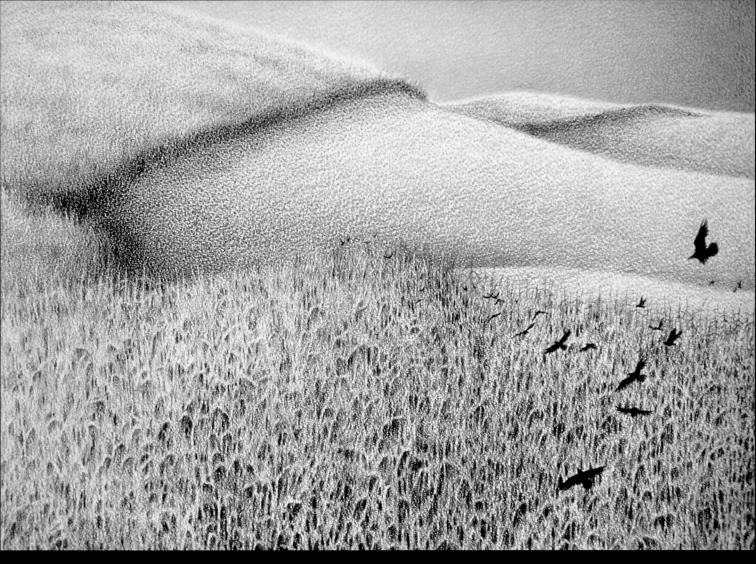

ALLAN SERVOSS
Indian Summer 13 ½" x 20 ½"

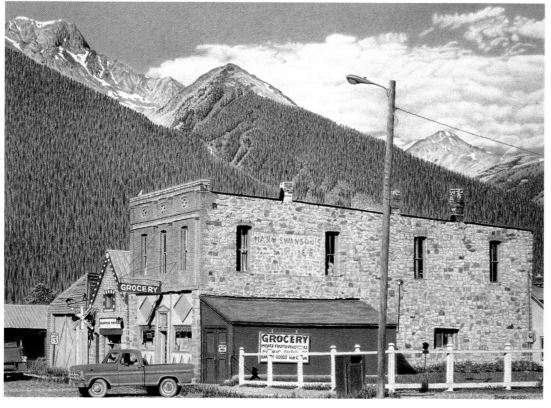

BRUCE NELSON
Silverton Colorado 18" x 24"

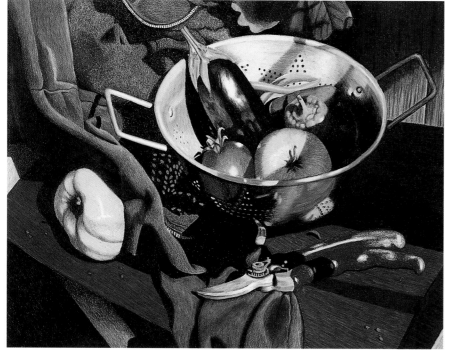

JOANNE SMITH WOOD
Backyard Labors 9¼" x 14¾"

DON PEARSON
Nymph Lake *(above)* 16" x 20"
Father & Son Chay *(below)* 11" x 17"

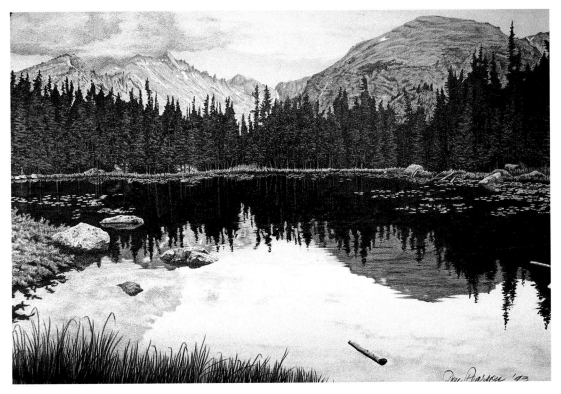

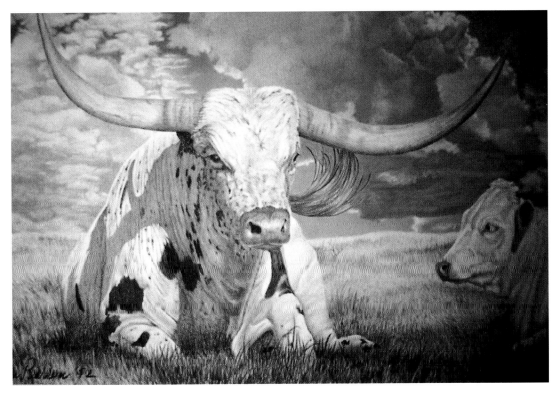

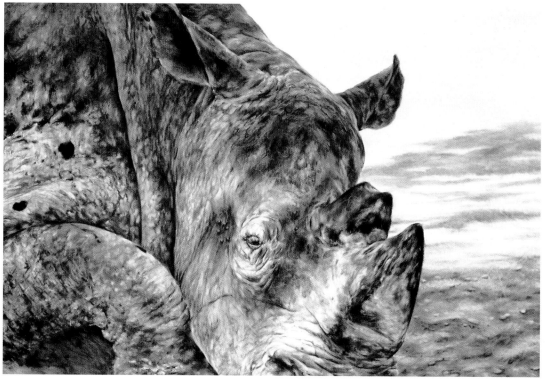

(clockwise from top)
HELEN JENNINGS
Kind Thoughts 15" x 23"
I'm Listening 15" x 22"

PATRICIA MILLER
Hippo 40" x 29"

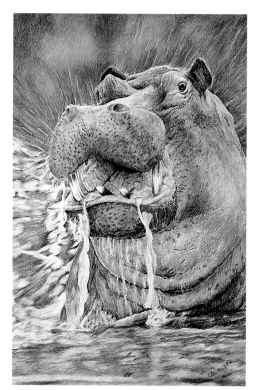

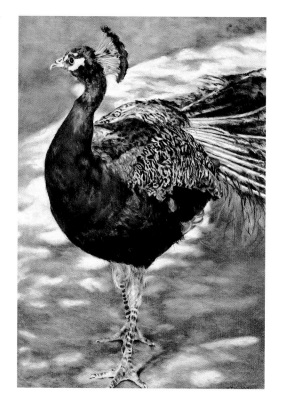

108

KATHI GEOFFRION PARKER
Bighorn Sheep 20" x 23"

SHERRY ANN McQUADE
The Gathering 13" x 18 ½"

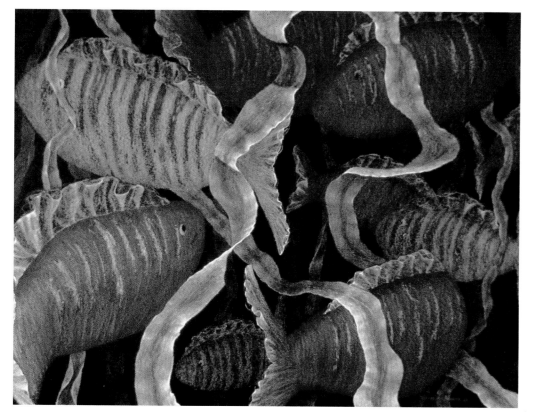

VALERA WASHBURN
Fish #3 23 ³/₈" x 27"

BARBARA D. REINHART
Hobo Robison 19" x 11"

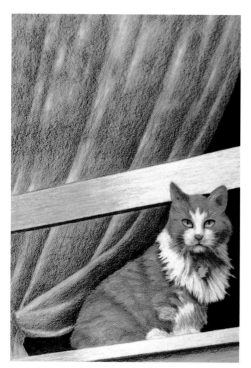

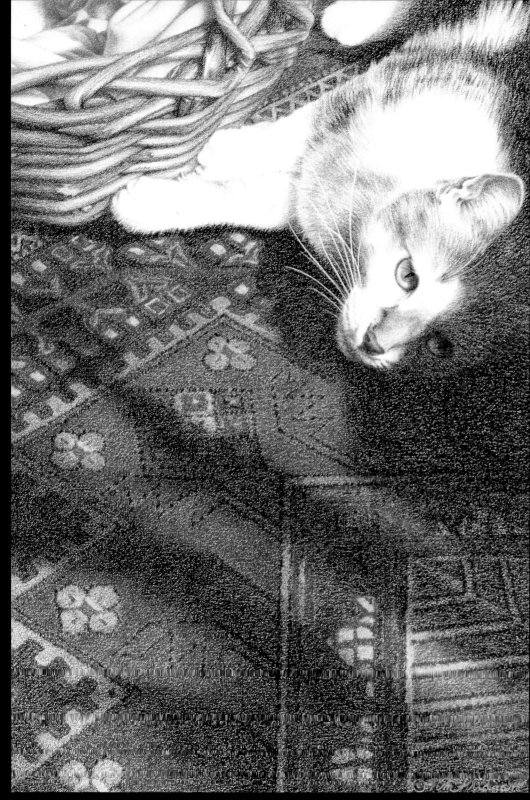

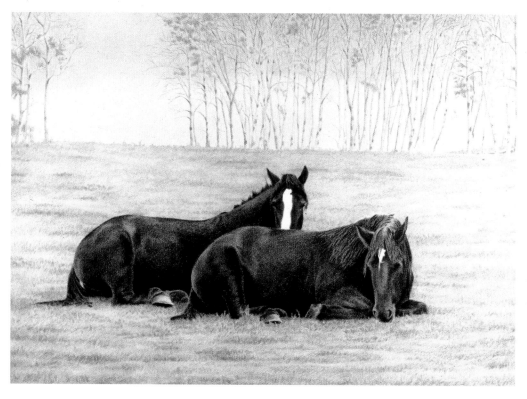

HEATHER DICKINSON
Horses in Field 13 ¼" x 17 ⅞"

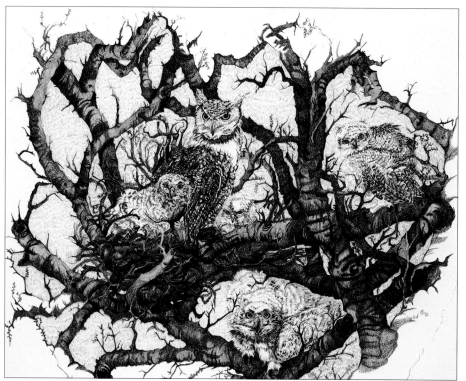

DONNA GAYLORD
Palo Verde Palace 29" x 35"

MARCHEL REED
When the Work is Over
14" x 18"

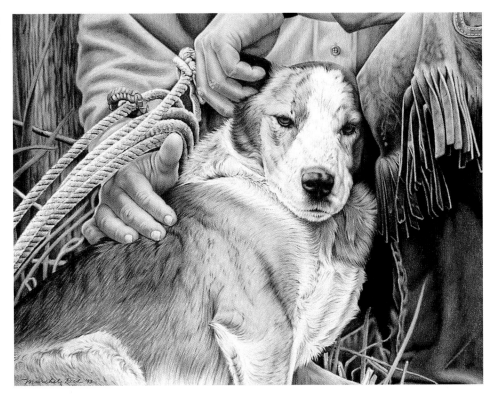

BARBARA ANNE RAMSEY
Just Old Gray Man
13" x 16"

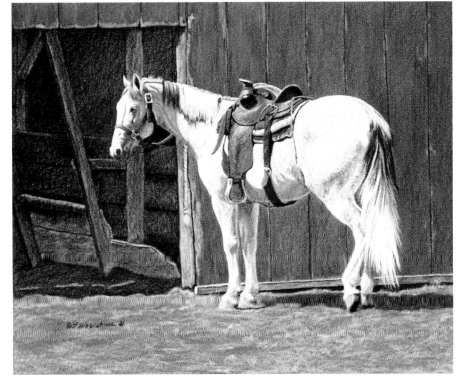

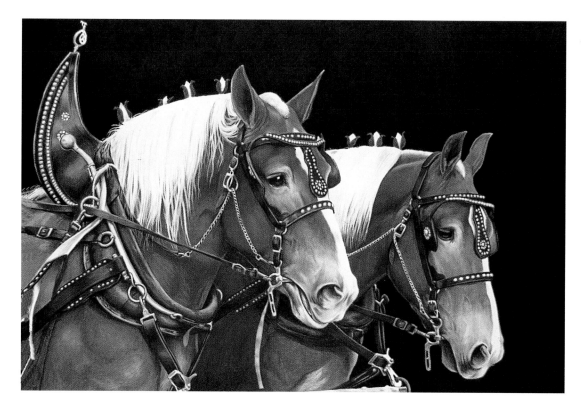

BETHANY A. CASKEY
The Good Team 14" x 18"

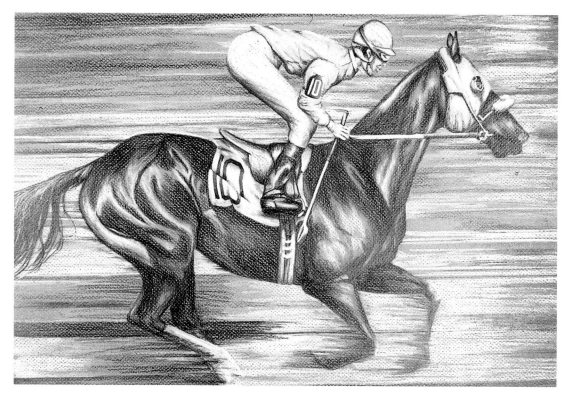

DONNA SCHIMONITZ
Moon Racer 21 ½" x 25 ½"

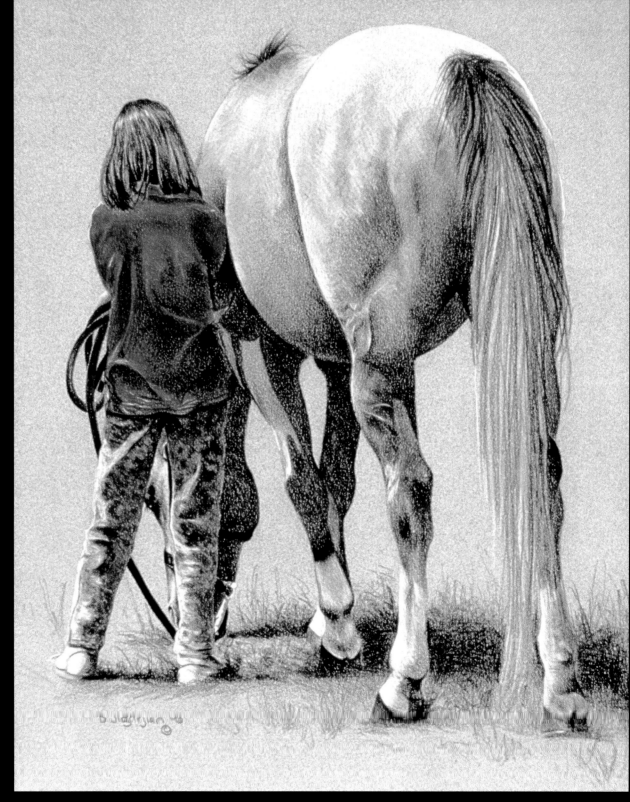

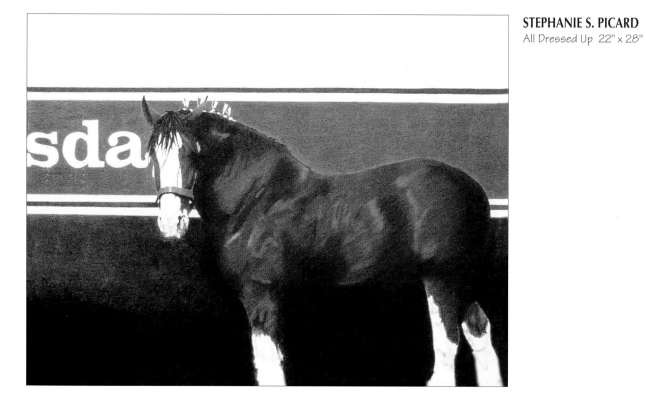

STEPHANIE S. PICARD
All Dressed Up 22" x 28"

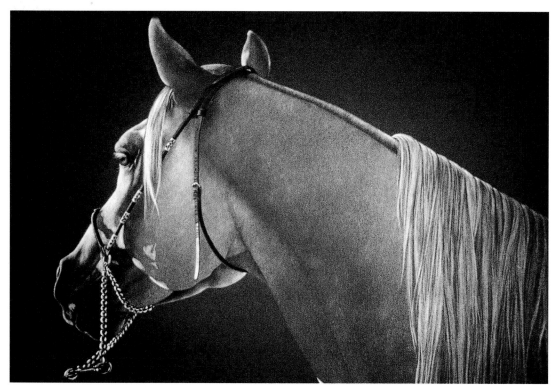

SHARON L. TURNER
Nizraff at Dawn
24 1/2" x 28 1/2"

THOMAS M. THAYER, JR.
Monkey Shines 17" x 22"

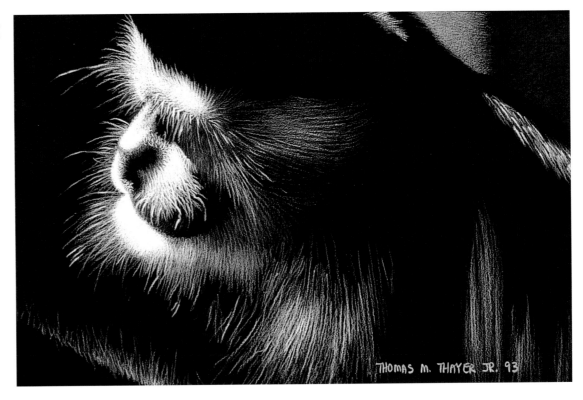

SUSAN Y. WEST
Abstracat 17" x 19 ¹/₂"

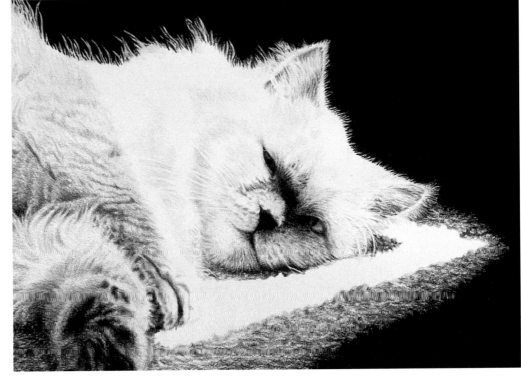

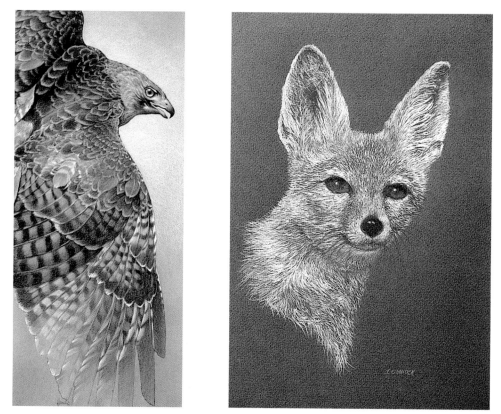

ROB FLEMING
Eye of thr Hunter 34" x 14"

JAN GUNLOCK
Kit Fox 23" x 26"

NANCY C. KESSEL
Loggerhead Turtle 28 1/4" x 34 1/4"

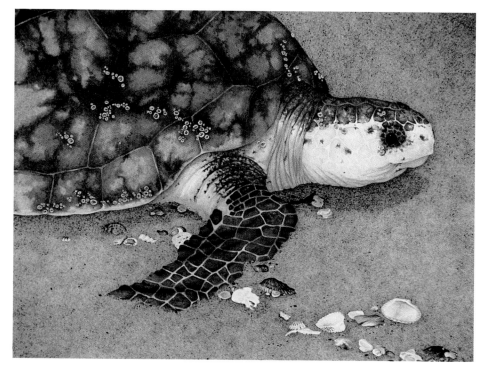

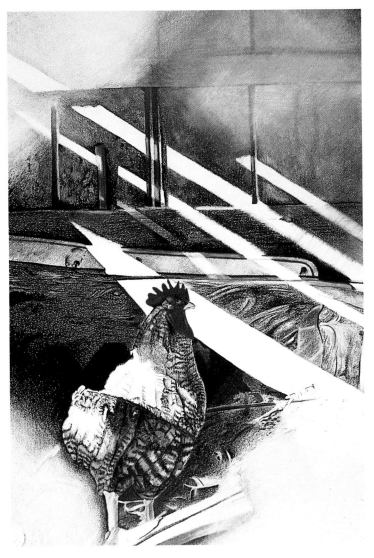

DR. CHRIS DAVIS
Mr. Ledford's Prize 28" x 23"

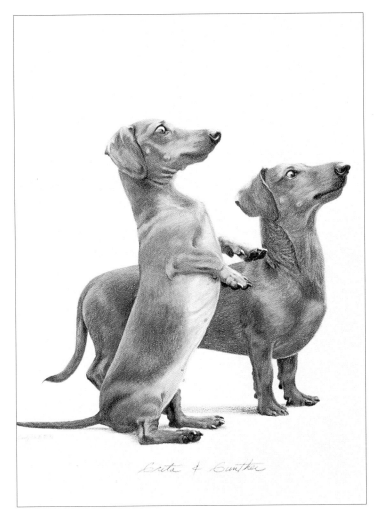

Greta & Gunther

SANDY WHITE
Greta & Gunther 20" x 20"

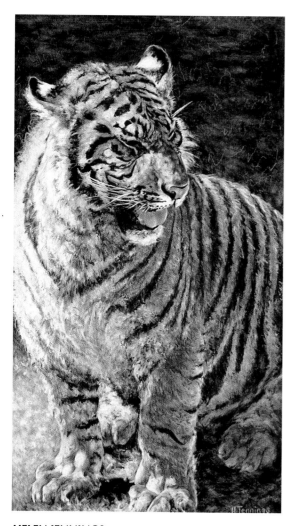

HELEN JENNINGS
Ready to Speak 26 ½" x 12"

GILBERT ROCHA
Classical Images II 22 ½" x 31 ¼"

JAN HENDERSON
African Ruler 20" x 16"
Contemplating Moment 20" x 16"

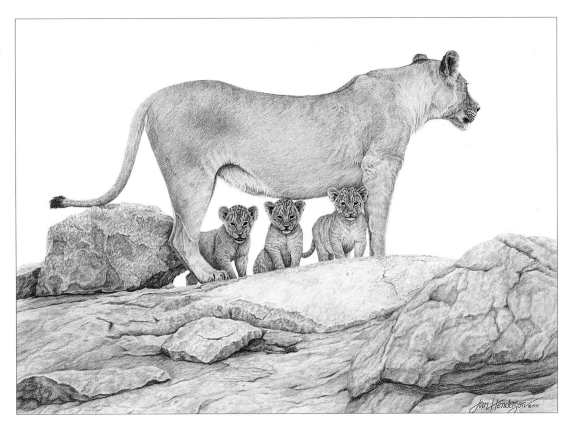

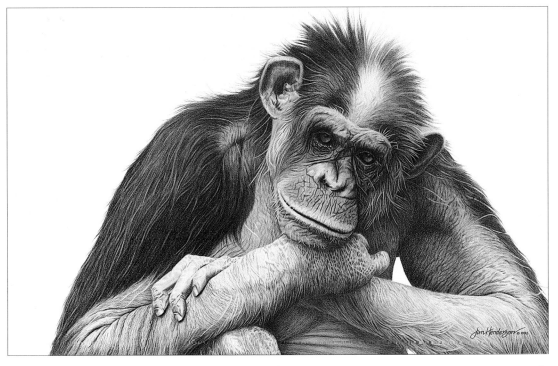

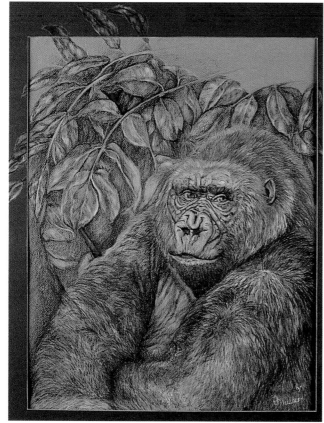

PATRICIA MILLER
Gorilla 30" x 26"

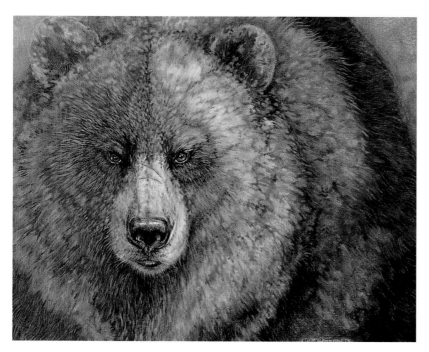

JUDY MEHN ZABRISKIE
Bear 23" x 27"

DON PEARSON
Family Picnic 8" x 10"

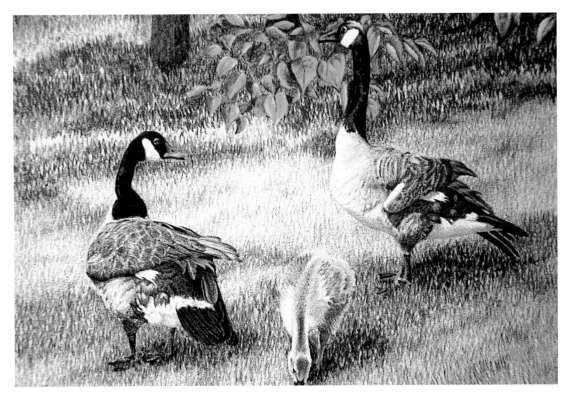

YVONNE E.M. WEINSTEIN
Cool Grey Geese, Wintersmith
20" x 29"

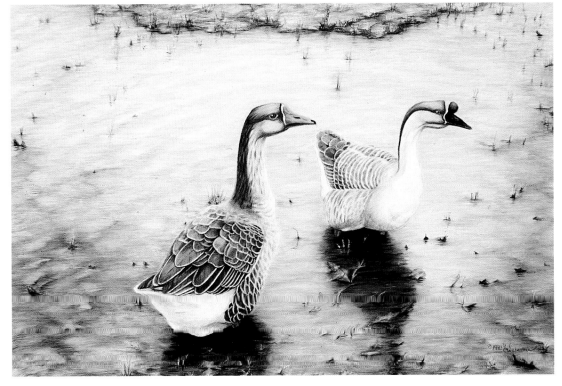

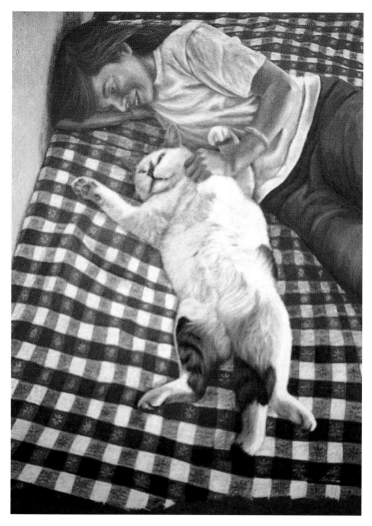

NANCY GARCIA
Quality Time 28" x 23"

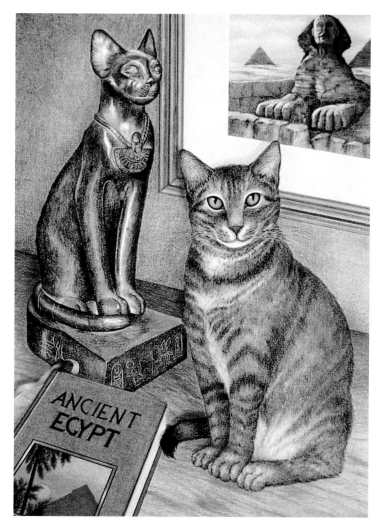

JOAN CHRISTENSEN
Past Kingdoms Revisited 23" x 17"

JOAN CHRISTENSEN
Egyptian History Buff
17" x 23"

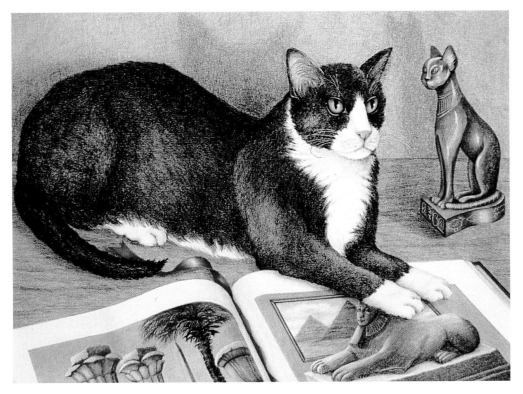

NAOMI M. PRIDJIAN
Niko in the Firethorns
14 ¹⁄₂" x 19"

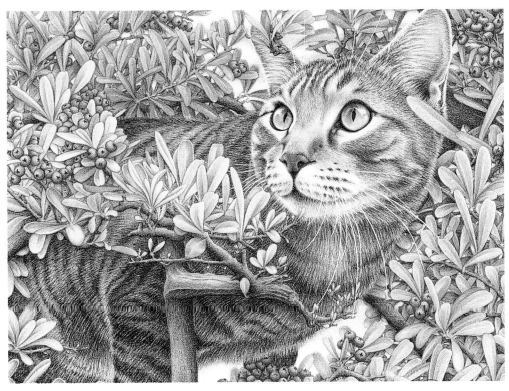

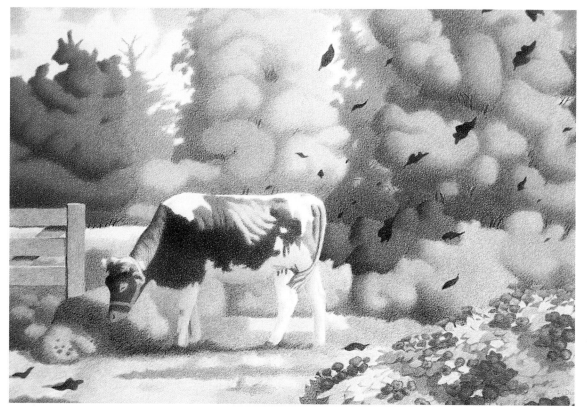

LAURA DUIS
Autumn Grazing
21 ½" x 27"

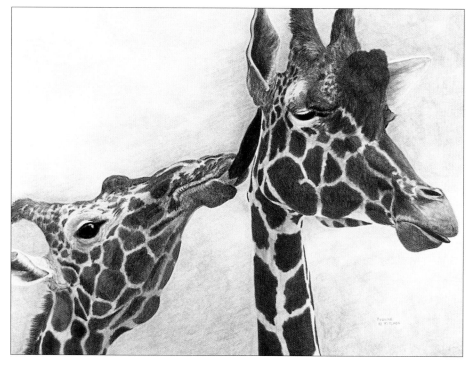

YVONNE KITCHEN, RN
Patches Loves Magic
27 ¼" x 33"

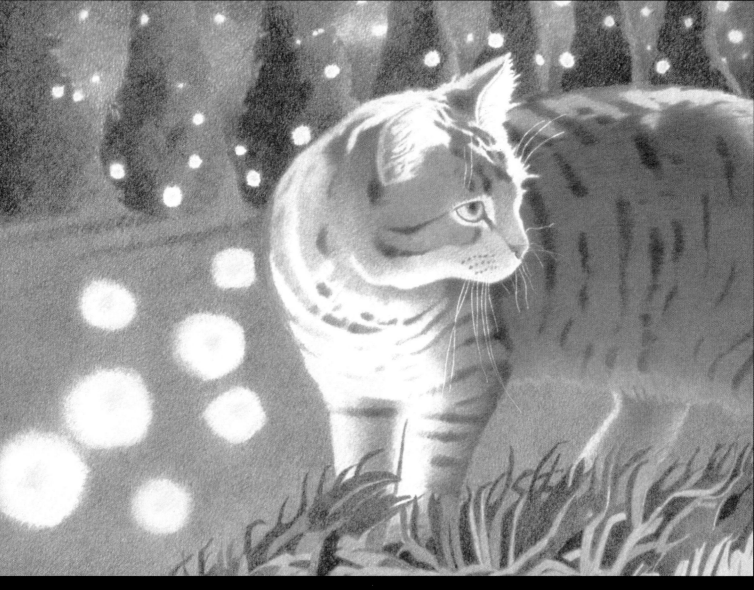

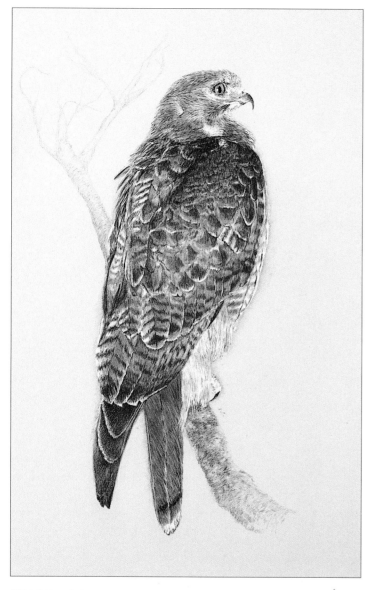
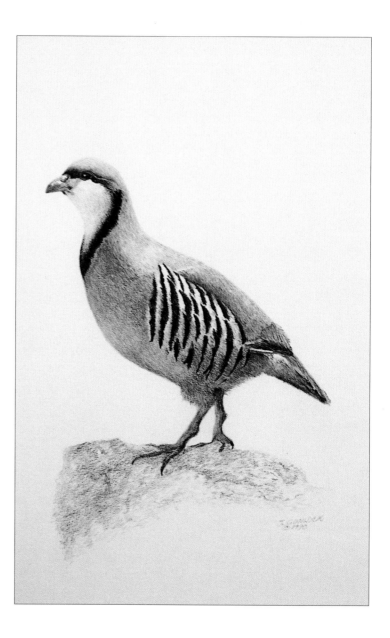

JAN GUNLOCK
Red Tailed Hawk *(left)* 25" x 31"
Chukar *(right)* 22" x 20"

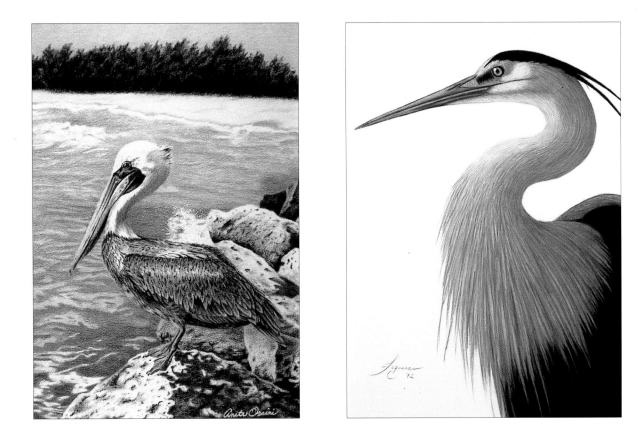

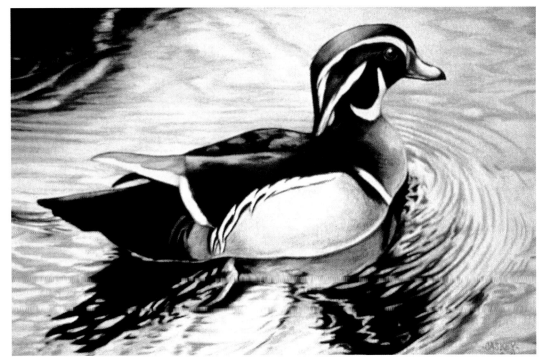

(clockwise from top left)

ANITA ORSINI
Dania 12" x 9"

RAMON FIGUEROA
Blue Heron 30" x 24"

BETHANY A. CASKEY
Wood Drake 6 ½" x 11"

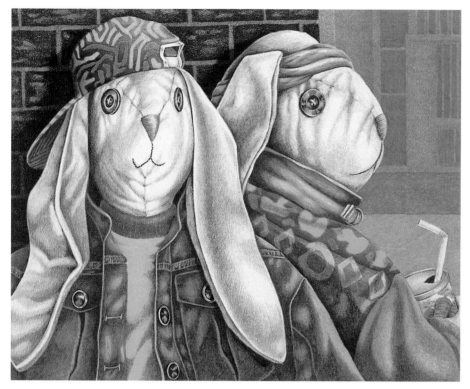

CINDY MIS SWIECH
Sam & Charly *(above)* 13 ½" x 17"
Bears of Summer *(below)* 14" x 22"

(facing page)
CHERIE L. LACY
Spirit of Sheep 30" x 30"

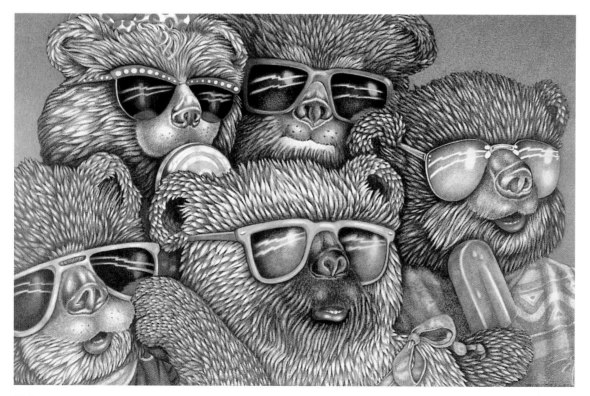

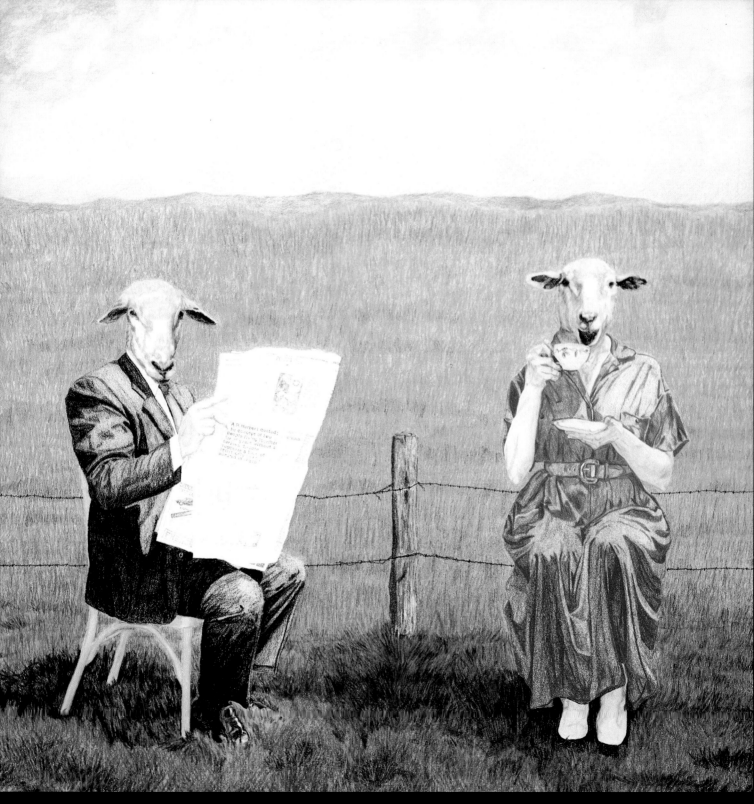

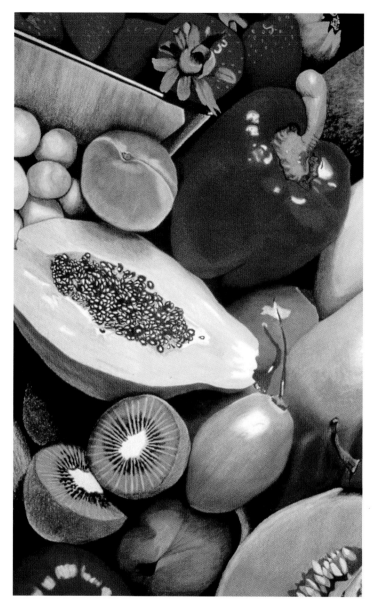

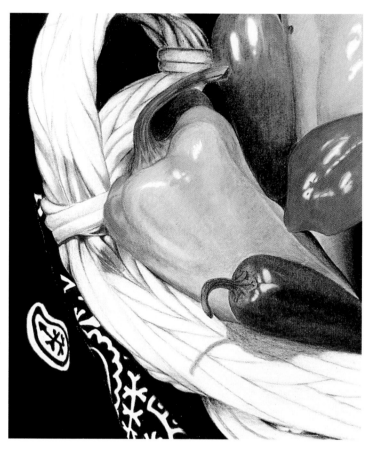

RICHARD TOOLEY
Peppers in Porcelain Basket 15" x 13 ½"

SUSAN KRONOWITZ
Fruits & Vegetables 40" x 30"

GARY GREENE
Bell Peppers 29" x 36"

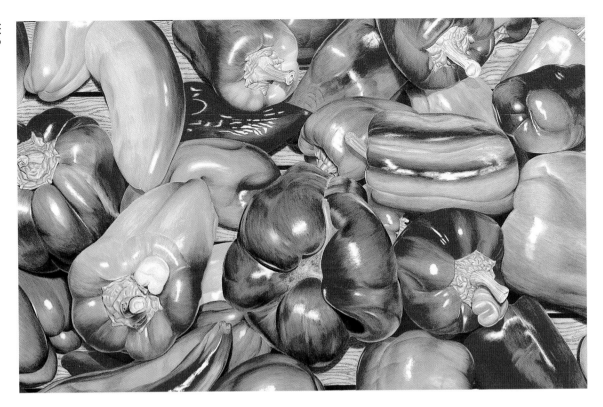

SUSAN KRONOWITZ
Fruit Salad 32" x 40"

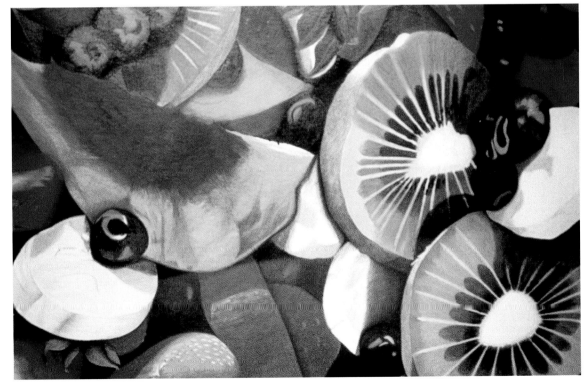

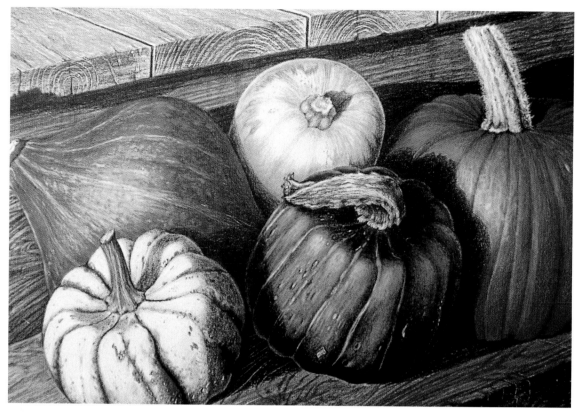

RUTH L. McCARTY
Squash 16" x 20"

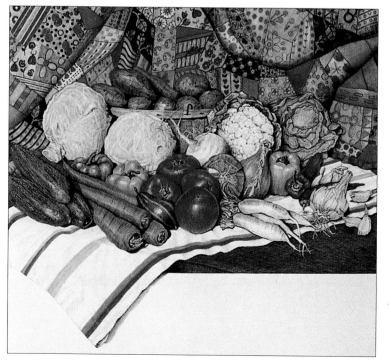

DORRIS L. DAUB
Country Colors 22" x 21 ³/₄"

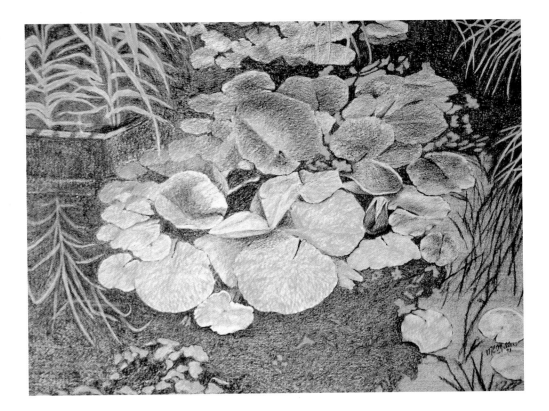

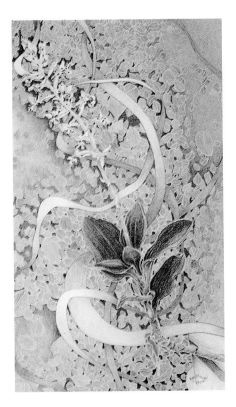

(clockwise from top left)

MARY ELLEN MILLER
Water Lily Mosaic 20" x 26"

PRISCILLA LYTCH
Haemaria Discolor 25" x 17"

RHONDA FARFAN
Closet Casualties 32" x 40"

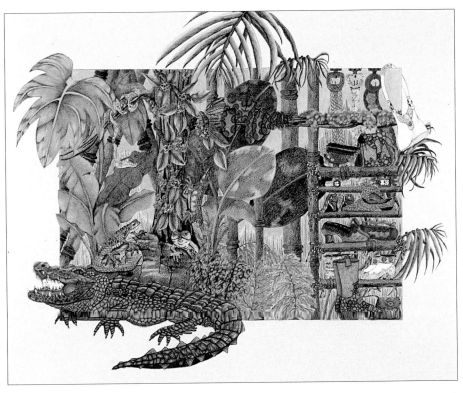

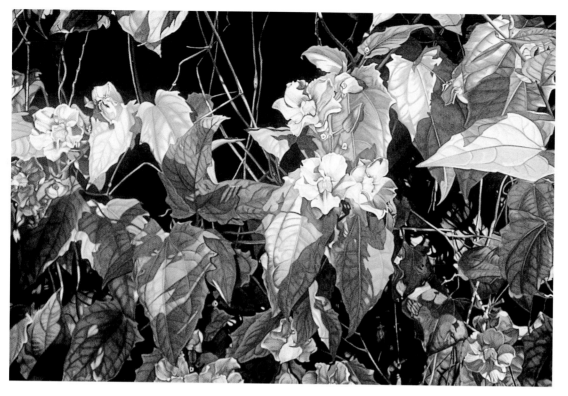

MARY POHLMANN
Clock Vine 24" x 36"
Artistic Merit Award

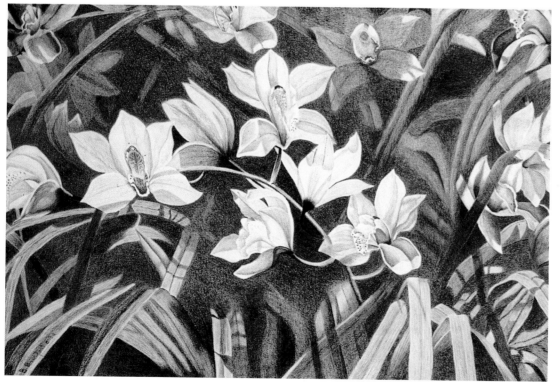

BOBBIE BRADFORD
Greenhouse #1 22" x 32"

SHELLY M. STEWART
Lightspray through
the Canopy
18" x 27"

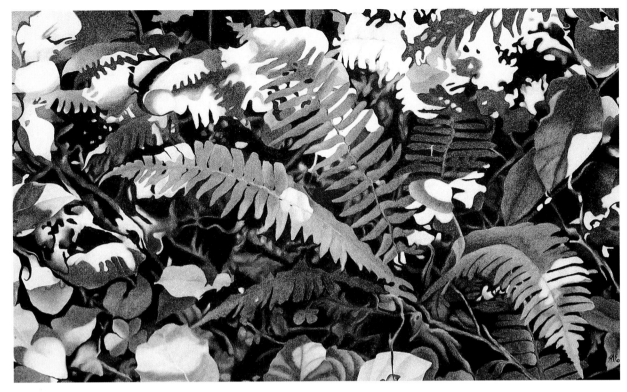

CAROLYN ROCHELLE
Second Growth 12 ¼" x 15"

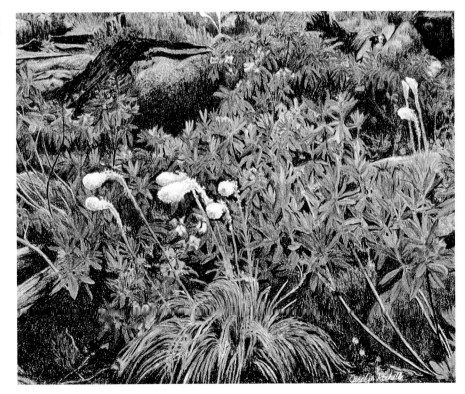

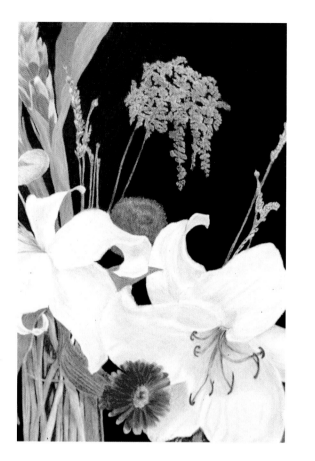

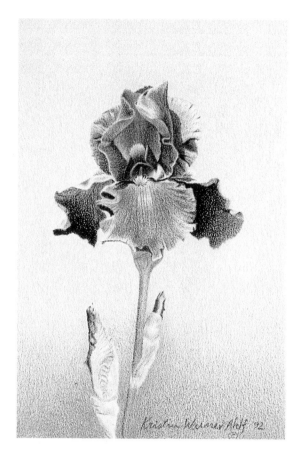

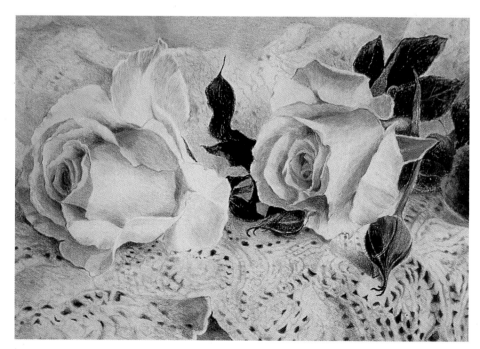

(clockwise from top left)

MARLENE ROGERS
White Lilies & Ginger 28" x 24 ½"

KRISTIN WARNER-AHLF
Bearded Iris II 5 ³/₄" x 4 ¼"

VIRGINIA H. BARBER
French Lace 10" x 15"

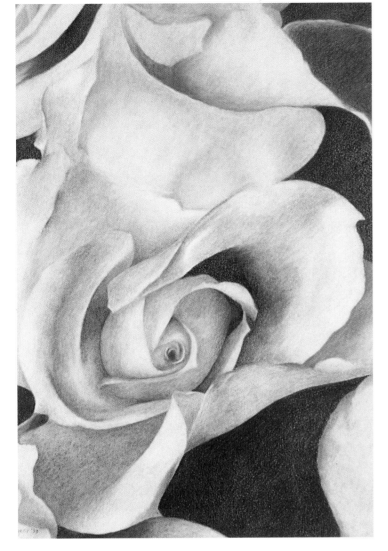

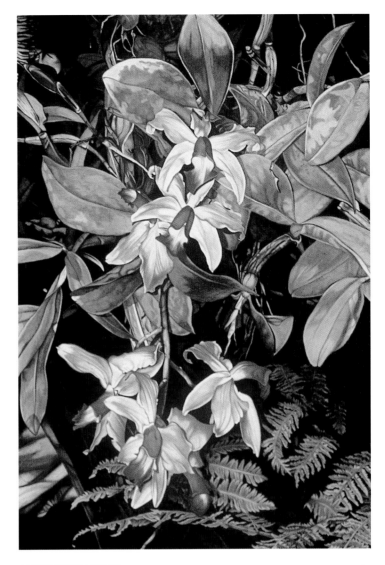

KATHLEEN RUHL-BOURGEAU
Genesis of Inner Peace 13" x 10"

MARY POHLMANN
Orchids 36" x 24"

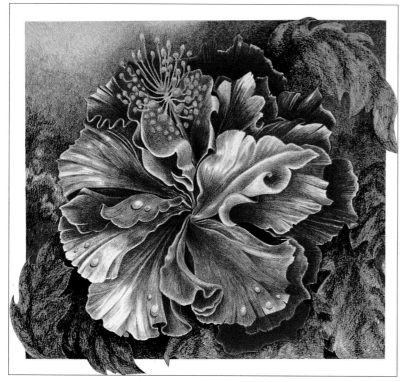

MARJORIE O'NEIL POST
Sun Dancer 28" x 29"

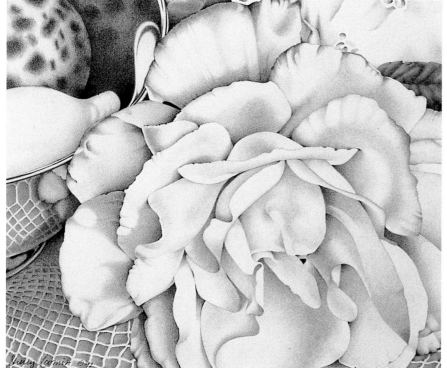

SHERRY LOOMIS
One Day Remaining 22" x 25"

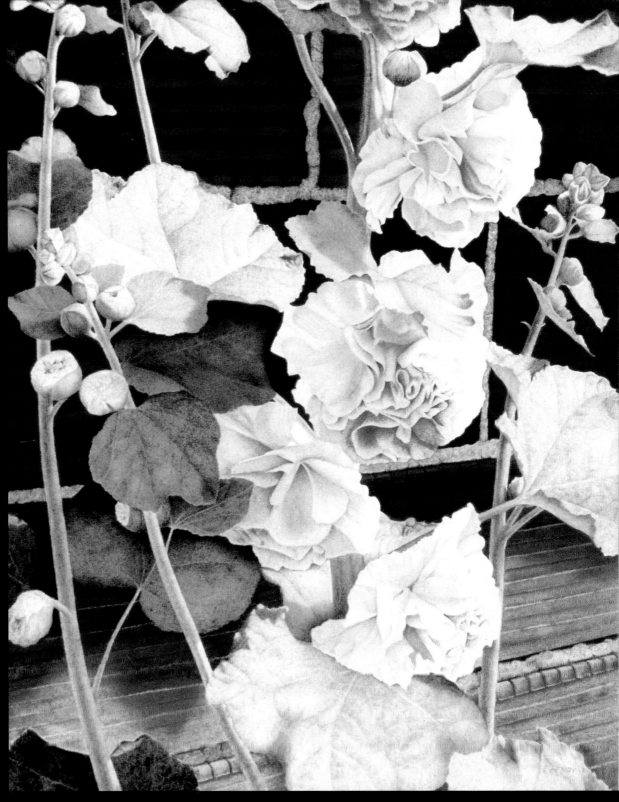

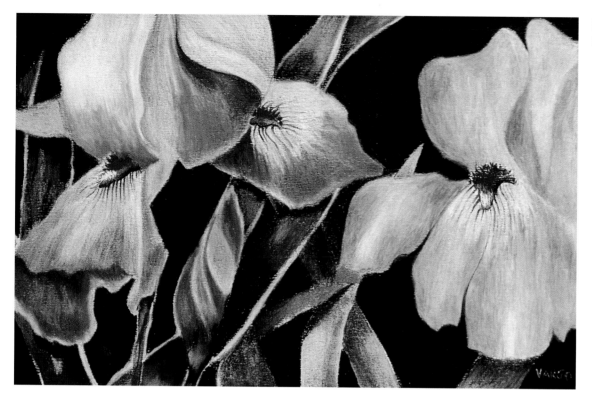

BOB VARGO
Iris Nocturne 5 ³/₄" x 9"

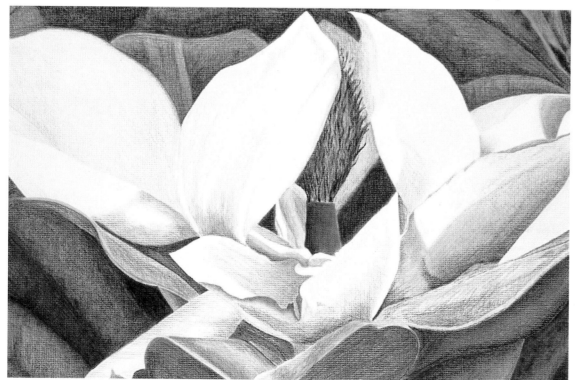

BOBBIE BRADFORD
Magnolia Grandiflora
15" x 23 ¹/₂"

CORA OGDEN
My Mother's Roses
19" x 32"

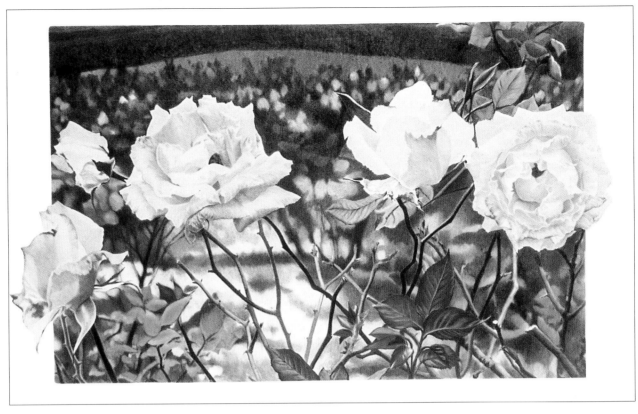

EVELYN F. PORTER
Rebirth 19 ½" x 25 ½"

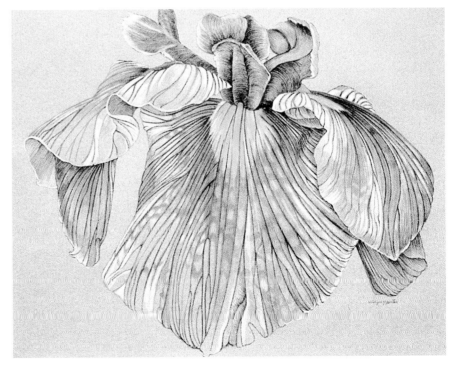

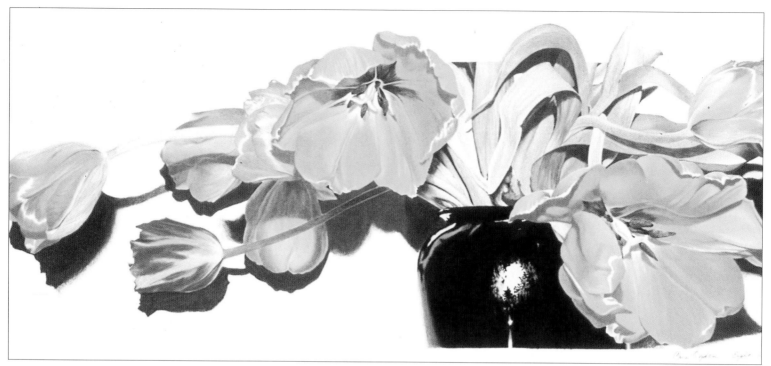

CORA OGDEN
Eight Tulips 18" x 30 ½"

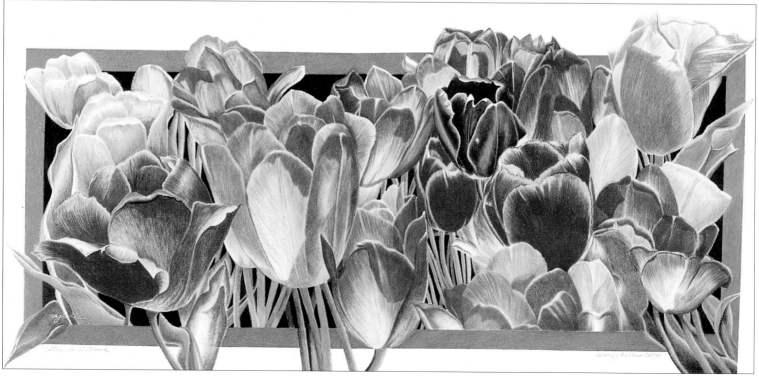

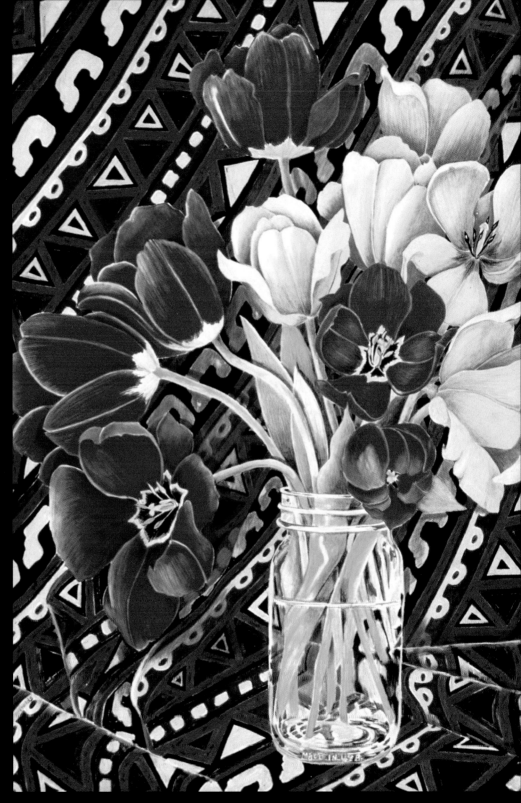

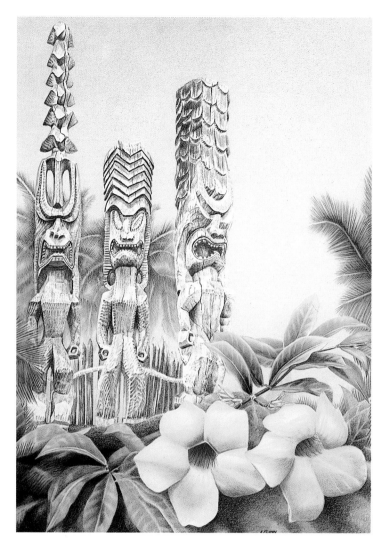

KATHARINE FLYNN
Guardians of the Sacred 19" x 15"

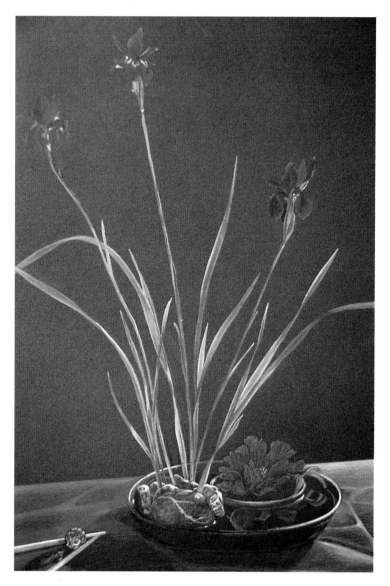

MARSHA WEIGAND
My Ikebana 40" x 32"

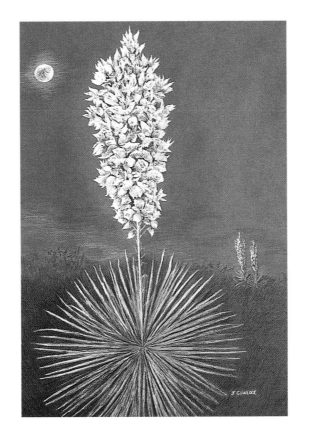

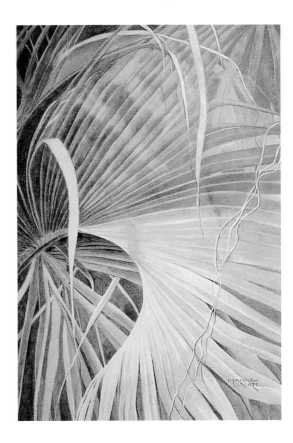

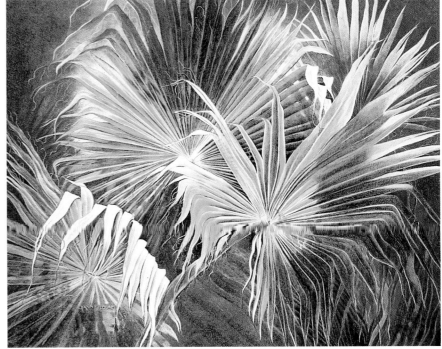

(clockwise from top left)

JAN GUNLOCK
Moon Yucca 30" x 33"

DYANNE LOCATI
Palm Leaves 23" x 15 ½"
Forest of Palms 32" x 40"

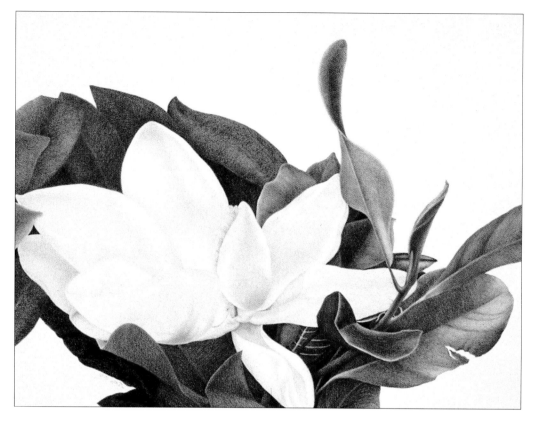

MOLLY LITHGO
Magnolia 26" x 30"

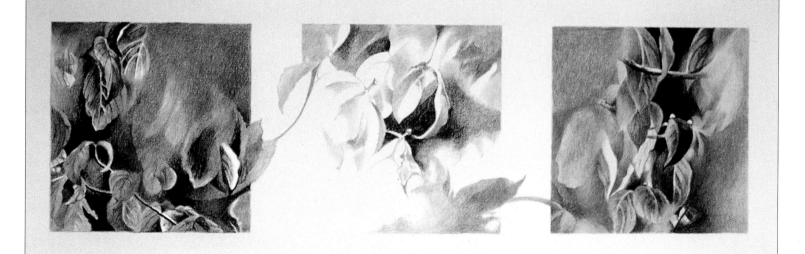

JEANNE TENNENT
In Between 8" x 18"

(clockwise from top)
TERRY SCIKO
Illuminated Lady 24 ¹/₂" x 28 ¹/₂"

PRICILLA HEUSSNER
Ornamental Kale 32 ³/₄" x 29 ¹/₂"
Oregon District Chapter Award

CARLA GOLDER
Succulent V 25 ¹/₂" x 34"

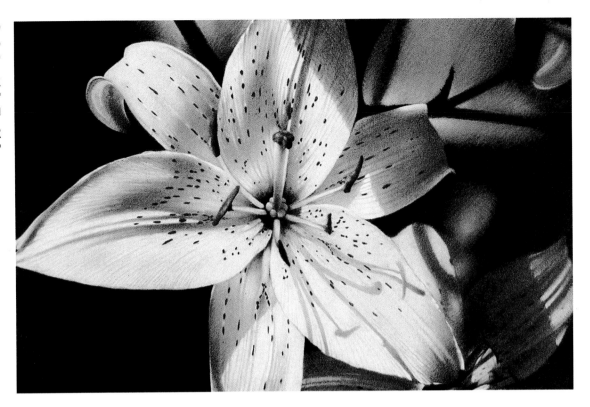

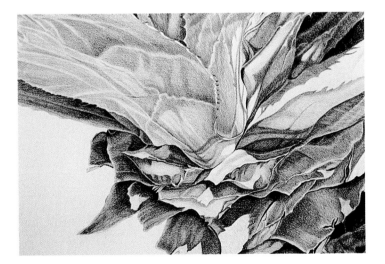

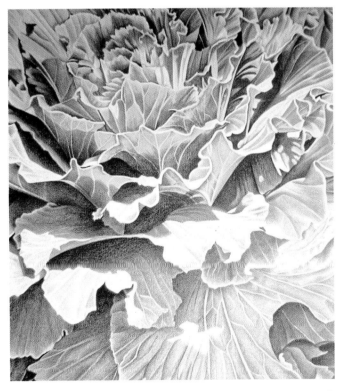

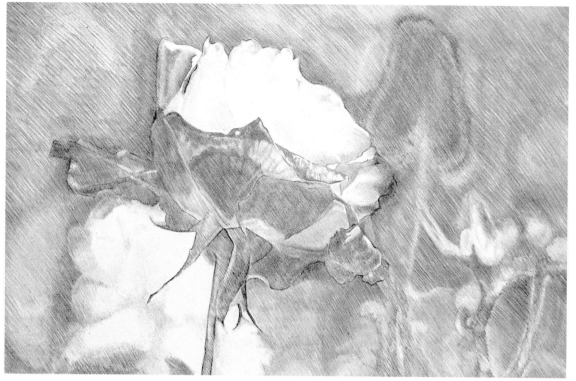

JANICE ROSENTHAL
Solar Rose 14" x 22"

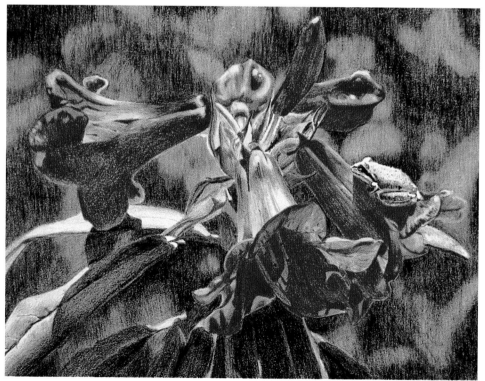

CAROLYN ROCHELLE
The Prince 8" x 10"

(clockwise from top)

PROCTOR P. TAYLOR
Tulips 11" x 15"

REBECCA BROWN-THOMPSON
Abutilon Menziesii 10" x 12"

EILEEN COTTER HOWELL
Cascade 29 ⅞" x 26"

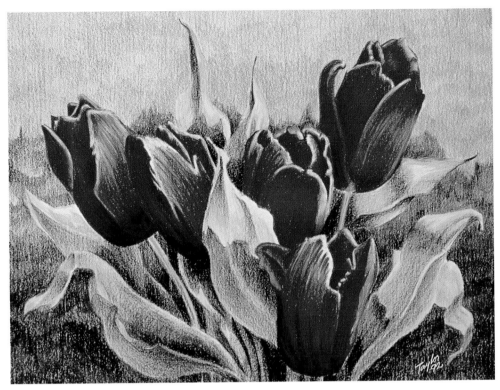

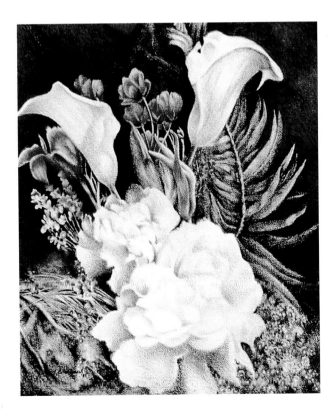

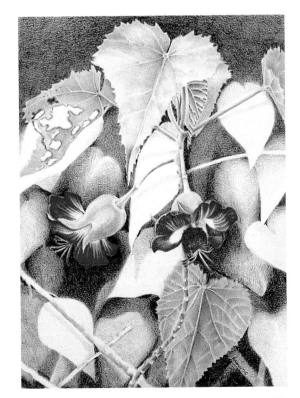

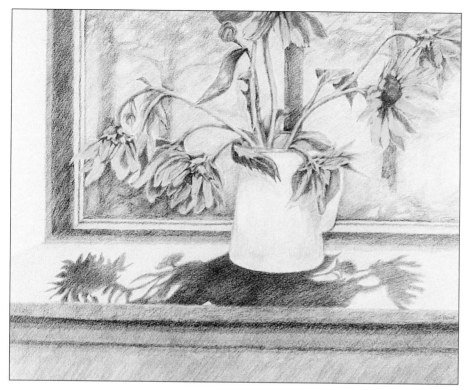

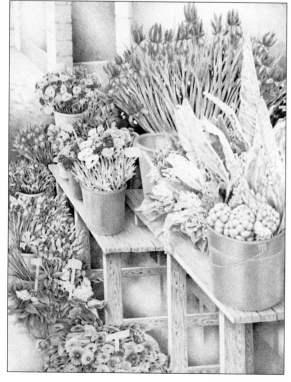

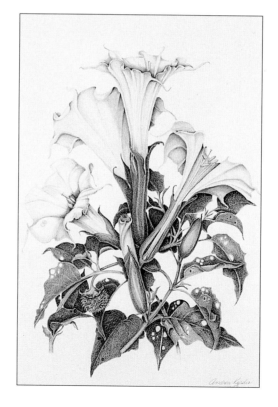

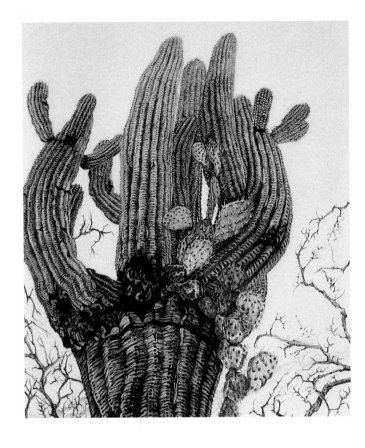

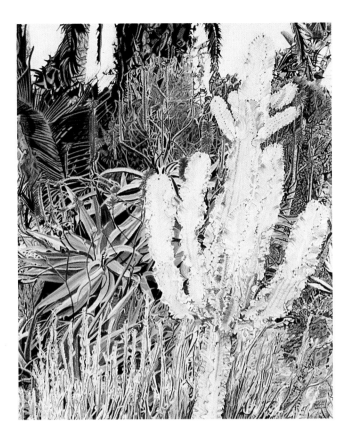

(clockwise from top left)
DONNA GAYLORD
Prickly Partners 35" x 29"

ROBIN WIENER
California Cactus 24 ½" x 21 ½"
Fuschia 11" x 11"

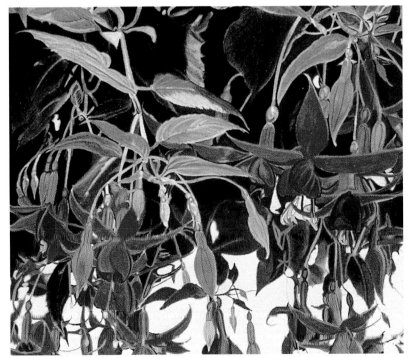

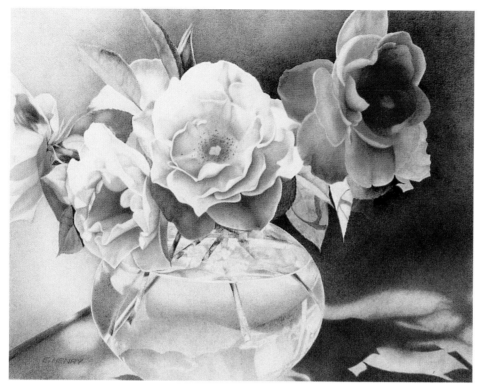

EDNA L. HENRY
Rose Bowl
10 ¹/₂" x 14"

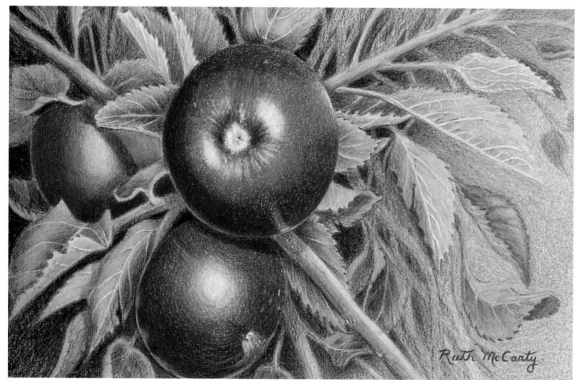

RUTH L. McCARTY
Apples 14" x 16"

154

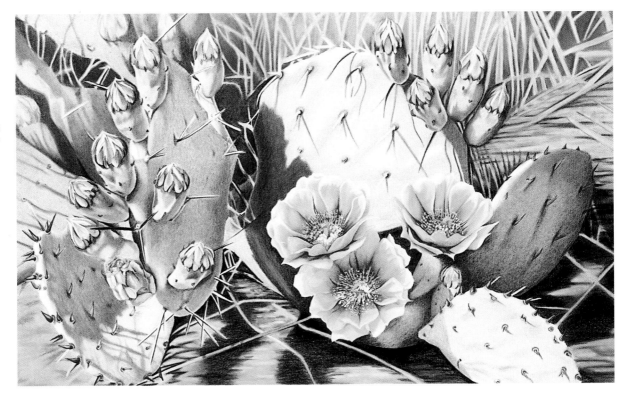

(clockwise from top)
KATHARINE FLYNN
Prickly Pear 16" x 19"

EDNA L. HENRY
Summer Song 11" x 15"

IRIS STRIPLING
Flowering Cabbage
14 ½" x 15 ½"

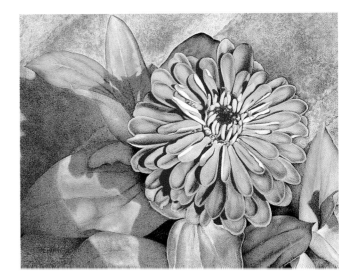

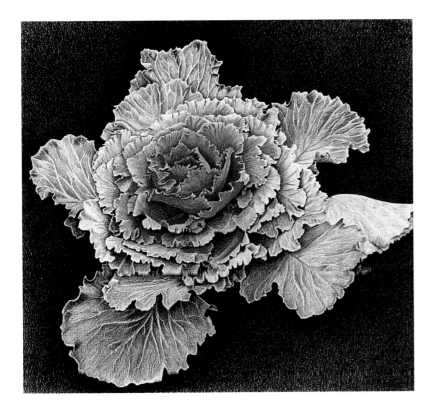

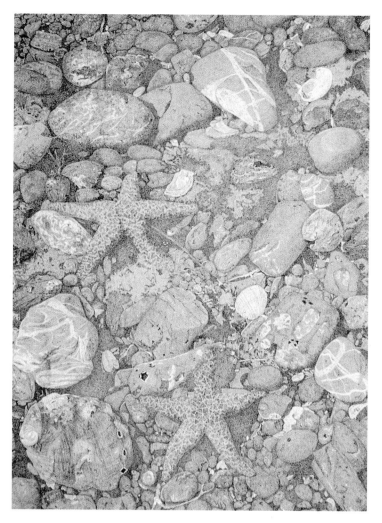

(clockwise from top left)

CINDY HOPKINS
Rock Stars 18" x 14"

SUSAN LANE GARDNER
Hydrangea 24" x 27"

JEANNE TENNENT
Threads of Nature 21" x 27"

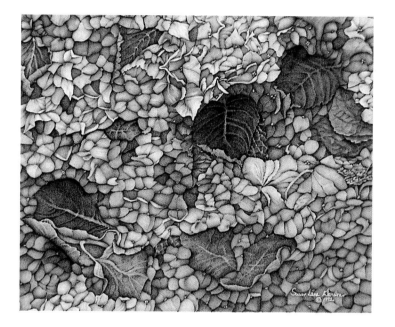

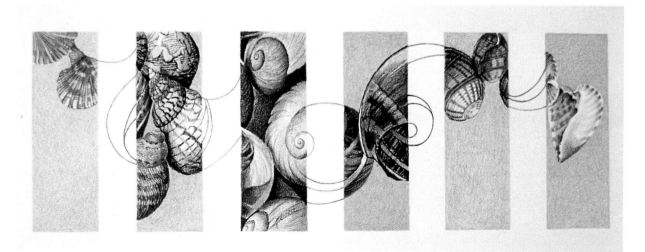

DIRECTORY

Deane Ackerman
117 Snowden Street
Sumter, SC 29150
803-775-6003

W. Nelson Ackerman
321 Lake Region Blvd.
Monroe, NY 10950
914-783-4690

Marianne Anderson
1072 Waterford Road
Bartlett, IL 60103
708-372-9130

Richard Asher
4907 Westshire NW
Comstock Park, MI 49321
616-784-8457

Bonnie D.Auten
213 E. Chicago Blvd.
Tecumseh, MI 49286
517-423-6184

Pat Averill
640 Ninth St.
Lake Oswego, OR 97034-2221
503-635-4930

Susan Avishai
28 Marlboro St.
Newton, MA 02158
617-969-5451

Gary Bachers
101 S. Maple
New Boston, TX 75570
903-628-2655

Jeffrey Smart Baisden
Rt. 7, Box 86
Live Oak, FL 32060
904-362-2635

Virginia H. Barber
204 NW 111th Loop
Vancouver, WA 98685
206-576-1643

Nancy Barnet
8928 Shady Vista Court
Elk Grove, CA 95624-2729
916-685-4147

Joe Bascom
1550 York Ave., Apt. 15E
New York, NY 10028
212-737-2191

Nancy Blanchard
Permanent School Road
Erwinna, PA 18920
215-294-9040

Lula Mae Blocton
798 Pudding Hill Road
Hampton, CT 06247
203-455-0820

Dale M. Bonin
152 Stone Meadow Lane
Madison, AL 35758
205-461-8192

Bobbie Bradford
1725 Wilstone Ave.
Leucadia, CA 92024
619-944-6246

Rebecca Brown-Thompson
N600 Wolf Lodge
Creek Road
Coeur D'Alene, ID 83814
208-664-3403

Margaret Ebbinghaus Burch
Rt. 1, Box 287
Anderson, MO 64831
417-775-2886

Eric Byars
RR#4
Flesherton, Ontario
NOC IEO
519-924-3578

Ralph D. Caparulo
122 Montclair Ave.
Monclair, NJ 07042
201-783-4736

Laurie Schirmer Carpenter
216 E. Jefferson St.
Blissfield, MI 49228
517-486-2790

Bethany A. Caskey
P.O. Box 263
112 S. Second St.
Albia, IA 52531
515-932-7508

Claudia Loomis Chandler
2411 NE 148th Ct.
Vancouver, WA 98684
206- 944-9222

Joan Christensen
420 Skidoo Lane
Polson, MT 59860
406-887-2515

Jim Cowen
99-72 66th Road
Forest Hills, NY 11374
718-830-0265

Vera Curnow
2773 Denise
Troy, MI 49930
810-828-7602

Dava Dahlgran
32 Suzanne St., Rt. 1
Washington, WV 26181
304-863-9310

Dorris L. Daub
519 Manor House Lane
Willow Grove, PA 19090
215-659-8601

Dr. Chris Davis
1071 River Road
Greer, SC 29651-8328
803-877-0801

Martha DeHaven
106 La Vista Drive
Los Alamos, NM 87544
505-672-3342

Charles Demorat
305 Cornelia Drive
Graham, North Carolina 27253
919-229-7359

Daniel C. Dempster
"Shellpoint" 10 Shellpoint Rd.
Tuckers Town, ST George's
HS02 Bermuda
809-293-0710

Patry Denton
2948 Pierson Way
Lakewood, CO 80215
303-237-4954

Sharon Di Giacinto
6741 W. Cholla
Peoria, AZ 85345
602-878-0844

Heather Dickinson
1857 Leclerc Rd., RR #2
Russell, Ontario
Canada K4R 1E5
613-445-3578

Gwen Dietrich
8744 Holly
Canton, MI 48187
313-453-1887

Sheri Lynn Boyer Doty
2801 So. 2700 E.
Salt Lake City, UT 84109
801-467-6013

Laura Duis
121 Mason Dr.
Dayton, OH 45405
513-274-5264

Roman Dunets
Rt. 4, Box 323
Glen Allen, VA 23060
804-550-3859

Joyce Dunn
N2676 Kutz Rd.
Fort Atkinson, WI 53538
414-563-9067

Barbara Edidin
1040 N. 22nd. Place
Phoenix, AZ 85028
602-493-1155

Robyn Ehrlich
1806 Mariner Dr., #311
Tarpon Springs, FL 34689
813-934-5331

Tim Ernst
3524 California Ave.
Carmichael, CA 95608
916-944-2207

Rhonda Farfan
25318 Ferguson Rd.
Junction City, OR 97448
503-998-3608

Nikki Fay
P.O. Box 422
Philomath, OR 97370
503-929-6318

Robin Fekaris
2135 Kolomyia
West Bloomfield, MI 48324
313-363-0880

Ramon Figueroa
122 Sandlewood Drive
Kissimmee, FL 34743
407-348-0258

Virginia Finn
950 Nottingham
Grosse Pt., MI 48230
313-331-7516

Susan Field
14 Asbury Ave.
Farmingdale, NJ 07727
908-938-7355

Rob Fleming
P.O Box 53
Driftwood, TX 78619

Katharine Flynn
2855 Southwest Dr.
Sedona, AZ 86336
602-282-1263

Judy A. Freidel
2382 Highway 7 North
Hot Springs, AK 71909
501-623-1139

Merren Frichtl
3311 Oberon St.
Kensington, MD 20895
301-946-2974

Brigita Fuhrmann
31 Front St.
Williamstown, MA 01267
413-458-4058

Christine Fusco
1159 W. Staver St.
Freeport, IL 61032
815-233-5509

Nancy Garcia
3156 Holmes Run Road
Falls Church, VA 22042
703-532-8460

Susan Lane Gardner
1320 Fourth St.
Columbia City, OR 97018
503-366-0959

Donna Gaylord
1980 W. Ashbrook
Tucson, AZ 85704
602-297-6257

Jane A. Gildow
5550 Worley Road
Tipp City, OH 45371
513-698-4555

Patti Gloss
5620 W. Higgins
Chicago, IL 60630
312-286-0142

Carla Golder
1066 47th Ave. #2
Oakland, CA 94601
510-534-9774

Jeanne Goodman
1334 Botetourt Gardens
Norfolk, VA 23517
804-627-3113

Alex Graham
1400 Dominic
Las Vegas, NV 89117
702-363-3286

Celine Gratton
788 Rue Du
Patrimoine
Prevost, Quebec
Canada JOR ITO

June Gray
3100 4th
Ave. South
Great Falls, MT 59405
406-453-2286

Gary Greene
21820 NE 156th Street
Woodinville, WA 98072
206-788-2211

Paul Grybow
387 Rochester
Costa Mesa, CA 92627
714-646-7941

Jan Gunlock
3804 Golf Lane
Las Vegas, Nevada 89108
702-646-2110

Robert Guthrie
3 Copra Lane
Pacific Palisades, CA 90272
310-454-7533

Karen Hartmann
36 Taber Rd.
Sherman, CT 06784
203-350-8787

Linda Heberling
828 Dellwood St.
Bethlehem, PA 18017
215-867-3885

Jan Henderson
P.O. Box 715
Midvale, VT 84047
801-534-7598 X515

Edna L. Henry
29650 SW Courtside Dr. #14
Wilsonville, OR 97070
503-682-8853

• Priscilla Heussner
916 Whitewater Ave.
Fort Atkinson, WI 53538
414-563-5346

• Wendy J. Hildebrand
P.O. Box 29
Chesterfield, NH 03443
603-256-6313

Mike Hill
2509 San Marcus
Dallas, TX 75228
214-328-7525

• R.K. Hillis
6741 W. Cholla
Peoria, AZ 85345
602-878-0844

Mary Hobbs
65 Carriage Stone Dr.
Chagrin Falls, OH 44022
216-247-4275

Joan C. Hollingsworth
2824 NE 22
Portland, OR 97212
503-287-6439

Blythe Holt
47 San Rafael Ct.
West Jordan, UT 84088
801-561-9215

• Janet Louvau Holt
2768 SW Talbot Road
Portland, OR 97201
503-227-7000

Phillip Michael Hook
4705 Knox Drive
Columbia, OH 65203
314-445-5899

• Cindy Hopkins
3444 Orchard Street
Weirton, WV 26062
304-797-7385

• Judith Howe
968 Coneflower Drive
Golden, CO 80401
303-526-1878

Eileen Cotter Howell
3040 Timothy Dr. NW
Salem, OR 97304
503-362-5386

Linda Hutchinson
1784 Tallmadge Road
Kent, OH 44240
216-673-3884

Helen Jennings
872 N. Oxford Ln.
Chandler, AZ 85225
602-786-5638

Denise Jigarjian
859 Applewilde Dr.
San Marcos, CA 92069
619-736-0040

• Michele Johnsen
RR1, Box 328A
Colebrook, NH 03576
603-237-5500

• Andrea Kessler
P.O. Box 8873
Rancho Santa Fe, CA 92067
619-756-1750

Nancy C. Kessel
11223 Barbara Cove
Eads, TN 38028
901-853-9796

Yvonne Kitchen, RN
2539 Pioneer Road
Talent, OR 97540
503-535-5365

• Jill Kline
342 Whetstone, #6
Marquette, MI 49855
906-228-2769

Dave Koenig
1141 Arms #13
Marshall, MI 49068
616-781-3111

• Susan Kronowitz
1167 Gail Drive
Buffalo Grove, IL 60089
708-634-9332

• Ann Kullberg
31313 31 Avenue SW
Federal Way, WA 98023
206-838-4890

Cherie L. Lacy
937 Grove Dr.
Louisville, CO 80027
303-665-9335

Ron Lightburn
803-1034 Johnson St.
Victoria, B.C.
Canada V8V 3N7
604-382-0043

Amy V. Lindenberger
825 E. Maple St.
N. Canton, OH 44720
216-494-8951

• Molly Lithgo
636 Cedar St.
Greensboro, NC 27401
919-275-1202

• Dyanne Locati
6720 Doncaster Dr.
Gladstone, OR 97027
503-659-6904

• Sherry Loomis
613 Myrtle Street
Arroyo Grande, CA 93420
805-489-6490

Rita Ludden
6330 Nicholson Street
Falls Church, VA 22044
703-534-0132

Jaqueline Lukowski
591 Cascade Dr.
Springfield, OR 97478
503-741-1956

• Priscilla Lytch
311 NE First St.
Ft. Meade, FL 33841
813-285-9866

Teresa McNeil MacLean
PO Box 1091
Santa Ynez, CA 93460
805-688-8781

• Paula Madawick
159 Piermont Ave.
Piermont, NY 10968
914-359-2597

• Gretchen Maricak
1040 Chapin
Birmingham, MI 48009
313-644-3001

• Dara Mark
P.O. Box 465
2730 Grand Ave.
Los Olivos, CA 93441
805-688-0925

• Sory Marocchi
5017 N. Shoreland Ave.
Whitefish Bay, WI 53217-5540
414-964-6562

• Karen Martin
110 Avis St.
Rochester, NY 14615 NY
716-647-3328

• Ann James Massey
116 Star Spirits, Box 1258
Santa Teresa, NM 88008
505-589-0770

Margurite D. Matz
207 Alden Road
Carnegie, PA 15106
412-276-0806

Randy McCafferty
305 Edgewood Road
Pittsburg, PA 15221 PA
412-371-4152

• Ruth L. McCarty
629 Crestview Dr.
Corunna, MI 48817
517-743-4392

Carla McConnell
729 W. Broadway
Montesano, WA 98563
206-249-4810

Katherine McKay
P.O. Box 5472
Richmond, CA 94805
415-477-4739

• Gregory S. McLellan
4200 Greenwood Ave.
Holt, MI 48842
517-694-0521

Sherry Ann McQuade
437 Myrtle Street
Laguna Beach, CA 92651
714-494-1010

Patricia Joy McVey
34155 Alta Oaks Rd.
Box 572
Alta, CA 95701-0572
916-389-2732

Elisabeth Miles-Neely
712 12th Street
Oregon City, OR 97045-1664
503-650-5035

• Mary Ellen Miller
515 Lakeview #106
Alliance, OH 44601
216-821-2982

Patricia Miller
2399 Ashurst Road
University Hts., OH 44118
216-321-5556

Cindy Mis Swiech
2782 First Street
Eden, NY 14057
716-992-4153

• Melissa Miller Nece
2245-D Alden Lane
Palm Harbor, FL 34683
813-786-1396

Robbin Belous Neff
5412 NW Princeton
#108
Silverdale, WA 98383
206-692-8788

• Bill Nelson
107 E. Cary St.
Richmond, VA 23219
804-783-2602

Bruce Nelson
461 Avery Rd. E.
Chehalis, WA 98532-8427
206-262-9223

Barbara Newton
17006 106th Ave. SE
Renton, WA 98055
206-271-6628

• Cora Ogden
9445 Plantation Way
Germantown, TN 38139
901-758-0207

Anita Orsini
1331 NE 3rd Ave. B
Ft. Lauderdale, FL 33304
305-522-0493

Kathi Geoffrion Parker
331 Ridgecrest Ave.
Los Alamos, NM 87544
505-672-1061

Stanley Pawelczyk
306 Monroe Dr.
Piedmont, SC 29673
803-269-7782

Don Pearson
7819 S. College Place
Tulsa, OK 74136
918-492-5832

Walter Peterson
2748 Long Lake Dr.
Roswell, GA 30075
404-998-0586

• Michael Petringa
59 Varnum St.
Arlington, MA 02174
617-643-2732

• Stephanie S. Picard
117 Klethla Trail
Flagstaff, AZ 86001
602-525-9265

• Mary Pohlmann
15398 NE 2nd Ave.
Miami, FL 33162
305-945-8570

Evelyn F. Porter
409 Moore Hill Road
Grahamsville, NY 12740
914-985-7229

Marjorie O'Neil Post
3475 NE 32 Ave.
Portland, OR 97212
503-335-0743

Naomi M. Pridjian
330 Sophia Street
West Chicago, IL 60185
708-293-4618

Barbara Anne Ramsey
1692 Grace Rd.
Gridley, CA 95948
916-846-4849

Marchel Reed
2514 Goshen Rd.
Bellingham, WA 98226

Bill Reichardt
1409-E Druid Valley Dr.
Atlanta, GA 30329
404-315-1240

Barbara D. Reinhart
551 Heather Lane
Frankfort, IL 60423-9718
815-469-3139

Yevonne M. Reynolds
18888 Hwy. 299
Blue Lake, CA 95525
707-668-5582

Valerie Rhatigan
32 Ridgewood Terrace
Maplewood, NJ 07040
201-762-3267

Barbara Richards
169 South Fifth
Rogers City, MI 49779
517-734-4451

Chuck Richards
1931 Ivywood
Ann Arbor, MI 48103
313-845-6486

Jan Rimerman
PO Box 1350
Lake Oswego, OR 97035
503-635-3583

Gilbert Rocha
153 Hillcrest Dr.
North Platte, NE 69101
308-534-4623

Carolyn Rochelle
6186 SE Nelson Rd.
Olalla, WA 98359
206-857-4857

Marlene Rogers
20342 Randall St.
Orange, CA 92669
714-532-4247

Janice Rosenthal
1539 Woodcrest Drive
Reston, VA 22094
703-709-7735

Kathleen Ruhl-Bourgeau
963 Nottingham
Grosse Pointe Park, MI 48230
313-331-8809

Cynthia Samul
15 Pacific St.
New London, CT 06320
203-442-5695

Timothy Santoirre
513 Worthington #7
Oconomowoc, WI 53066
414-569-1786

Gary D. Sauls
4800 Saddlebrook Ln. #7
Louisville, KY 40216
502-448-6673

Donna M. Schultz
4753 Elm Hwy.
Posen, MI 49776
517-766-2576

Barbara Schwemmer
22 Coronado Shores
Lincoln City, OR 97367
503-764-2417

Terry Sciko
1450 Bonnie Road
Macedonia, OH 44056
216-467-1259

Allan Servoss
330 Lincoln Ave.
Eau Claire, WI 54701
715-832-1758

Sue Shanahan
11505 W. 193rd St.
Mokena, IL 60448
708-479-1403

Penny Thomas Simpson
3501 Thunder Rd.
Alamorgordo, NM 88310
505-434-1953

Wayne Spector
107 Midwood Road
Glen Rock, NJ 07452
201-445-7425

Constance W. Speth
1006 E. Third
Ellensburg, WA 98926
509-925-2737

Shelly M. Stewart
302 W. Fifth, P.O. Box 296
Albion, WA 99102
509-332-8926

Pat Stolte
11B Beacon Village
Burlinton, MA 01803
617-270-5780

Iris Stripling
4610 Somerset Ct.
Kent, WA 98032
206-854-5704

Brad Stroman
12 Locust Drive
Elizabethtown, PA 17022
717-367-7543

Deborah Stromsdorfer
3602 Grenobie Ct.
Rockford, IL 61114
815-282-9645

Don Sullivan
912 So. Telluride St.
Auroura, CO 80017
303-671-9257

Jeannine R Swarts
3741 S. Sunnyfield Dr.
Copley, OH 44321
216-666-9639

H. J. Taylor
1351 Le Burel Pl.
Brentwood By
British Columbia, Canada
VOS IAO
604-652-5249

Proctor P. Taylor
121 Valentine Dr.
Long Beach, MS 39560
601-863-4669

Sharon Teabo
30 Water Street
Petersburg, WV 26847-1545
304-257-2341

Michael Teague
79-990 Bermuda Dunes Dr.
Bermuda Dunes, CA 92201
619-345-3846

Jeanne Tennent
1010 Puritan
Birmingham, MI 48009
313-647-1115

Thomas M. Thayer, Jr.
3903 173rd. PL. SW
Lynnwood, WA 98037
206-743-2442

David John Thompson
6813 Lenbern Rd.
Baltimore, MD 21207 MD
410-265-5376

Richard Tooley
1281 West Wood St.
Decatur, IL 62522
217-423-2961

Marvin Triguba
1463 Rainbow Drive NE
Lancaster, OH 43130
614-687-1338

Sharon L. Turner
4100 North High
Columbus, OH 43214
614-268-3729

Gregg Valley
128 Thomas Road
Mc Murray, PA 15317
412-941-4662

Margo VanHorn
2090 Delano, Box 32
Oxford, MI 48371
313-628-9375

Bob Vargo
414 Austin Drive
Fairless Hills, PA 19030
215-946-1389

Diane Vestin
269 Crosby Rd.
Cloquet, MN 55720
218-879-6915

Ronni Wadler
8 Mardon Road
Larchmont, NY 10538
914-834-2116

Janet C. Walker
1123 West First St.
Oil City, PA 16301

Susan Walsh
416 E. Wilson St.
Madison, WI 53703
608-255-7135

Beth Ward-Donahue
1228 E. Brooks Road
Midland, MI 48640
517-631-1498

Kristin Warner-Ahlf
P.O. Box 241
So. Cle Elem, WA 98943-0241
509-674-5729

Valera Washburn
2255 NW Johnson, #305
Portland, OR 97210
503-229-0859

Marsha Weigand
22207 Innsbrook Dr.
Northville, MI 48167
313-477-3452

Yvonne E.M. Weinstein
4009 Congress Court
Abilene, TX 79603
915-675-5121

Phil Welsher
27 Sturwood Dr.
Belle Mead, NJ
908-874-0959

Linda Wesner
2834 Honey Tree Drive
Germantown, TN 38138
901-753-6524

Susan Y. West
5840 Glenn Springs Road
Spartanburg, SC 29302
803-573-9847

Sandy White
1869 Glenfield Dr.
Ortonville, MI 48462
313-627-6170

Robin Wiener
18 Broadview Ave.
Maplewood, NJ 07040
201-763-8150

Jane Willis
859 Cross Gates Blvd.
Slidell, LA 70461
504-641-3164

Phillip Wilson
4405 Dresden Road
Zanesville, OH 43701
614-453-4905

Joanne Smith Wood
2020 Evergreen
Salt Lake City, UT 84109
801-272-9626

Judy Mehn Zabriskie
5706 Tonyawatha Trai
Monona, WI 53716
608-223-0191

Robert Zavala
695 Old Beaumont Hwy.
Silsbee, TX 77656
409-385-6462

Deborah L. Zeller
871 Glen Oak Street
Glen Ellyn, IL 60137
708-790-1824

• = CPSA International Color
Pencil Exhibitor